AFRICA

AFRICA

◆

A PHOTOGRAPHIC SAFARI

Carlyle Thompson

A photographer blessed and knows it

iUniverse, Inc.
New York Bloomington Shanghai

AFRICA
A PHOTOGRAPHIC SAFARI

iUniverse books may be ordered through booksellers or by contacting:

iUniverse
1663 Liberty Drive
Bloomington, IN 47403
www.iuniverse.com
1-800-Authors (1-800-288-4677)

Because of the dynamic nature of the Internet, any Web addresses or links contained in this book may have changed since publication and may no longer be valid.

The views expressed in this work are solely those of the author and do not necessarily reflect the views of the publisher, and the publisher hereby disclaims any responsibility for them.

ISBN: 978-0-595-44388-8 (pbk)
ISBN: 978-0-595-69188-3 (cloth)
ISBN: 978-0-595-88717-0 (ebk)

Printed in the United States of America

All praise to my Lord and Savior, Jesus Christ!

I give thanks.

Carlyle Thompson

Dedicated to the memories of

Rev. Genell Buckner
&
Rosa Mae Buckner

Special thanks to

K's Art & Frame
17527 State Hwy 249
Houston, Texas 77064
Telephone: (281) 894-1107
Fax: (281) 894-1109
www.KsArtandFrame.com

Karisia Limited
and staff
PO Box 15283
Nairobi, 000509
Kenya
Telephone: (254) 208891168
Fax: (254) 20890266
Kerry-Glen.com
Kerry@Kerry-Glen.com

PhotoSource
5106 Louetta
Spring, Texas 77379
(281) 370-2220

I would like to thank my friends at PhotoSource for their continued support. Rodney, Karen, Rachel, Todd, Kelly, Eddie, and Steve, Your contribution to this project is greatly appreciated.

Contents

Introduction

It all started two years ago, on October 24, 2006. The Lord truly blessed me. As a teenager, I had always wanted to visit Africa. I had heard from so many people that Africa was the place where the history of black people began. I had waited so long for this day, and it felt like I was going home to meet and greet relatives and friends out of a spiritual dream.

Having the eye of a photographer, I wanted to share my personal experiences in Africa with others across the globe, not only by means of photographs, but also through words. I'm so thankful and blessed to show not only the young people, but also the elders of today's society, that all God's children must realize how truly blessed we are, no matter what corner of the globe we call home. Whether we have or have not, it's critical to remember to thank God and continue to give him all the praise and all the glory.

Sitting in the Chicago airport, I stared out of a large window, watching the planes as they taxied slowly on the runways like traffic during rush hour. Suddenly, a strange feeling hit me. Even though I'd been in airports many times, it felt a little different. It felt like my friends in Africa were just a few minutes away. The wait before boarding passed quickly, and before I knew it, the aircraft was moving from the gate and the large city disappeared before my eyes. London was the next destination in the long journey. We seemed to cruise along quickly, and before I knew it, the city of Nairobi was calling my name.

The captain announced we would be landing in the next few minutes. As I glanced out of the plane's window, I could see that day had transformed into night. The flight had been long and tiresome, but it was not a time to feel tired or sleepy. The constant dipping of the plane had made my stomach feel as if I were riding an elevator downward,

out of control. I heard the tires squeak as we landed—an indication that the Lord had blessed me in allowing me to visit Nairobi, my home away from home. Quickly disembarking from the aircraft, I felt the warm welcome of the Kenyan people and saw smiles that I had never seen before.

As I left customs, I saw what seemed to be a small city's worth of Kenyans welcoming us to their country. My eyes immediately started to search for my safari hosts, Kerry and James. The Christians were somewhere in the waving crowd of onlookers. Some greeted their loved ones, while others greeted visitors from other countries, like me. I could tell that the lengthy flight was beginning to take its toll on my eyes; my vision bounced through the crowd of people like a ball being slapped around in a pinball machine. Just as my tired eyes were trying to convince me to give up, I finally zeroed in on the husband-and-wife team, and they immediately embraced me as if we had known each other for years. Because of the nice reception I received from my new-found friends, I was now ready for anything.

They quickly whizzed me off to the hotel, where I would prepare myself for the next few, important days of my life by getting a good night's sleep. Before going to bed, I quickly scanned the itinerary that Kerry and James had prepared. Everything looked okay except for one minor problem: I had never flown in such a small airplane before. I was almost ready to cancel the safari entirely out of the fear that gripped me. There were times when I had to keep reminding myself that for every problem, there was an answer. Just a small prayer could solve any problem, because I knew the Lord would be with me at all times as I made this journey.

First Day of Camp: Into Africa

A brand new day began, and I introduced myself to a Kenyan breakfast buffet, which was truly fantastic. After my hearty breakfast, James bumped into me as I was checking out of the hotel. He transported me to the small community airport for the Cessna flight to a small town called Nanyuki. The edge of the city sits on the equator that divides Africa into northern and southern regions. After landing in Nanyuki, I would come face to face with my guide Lenjoh for the first time. The Christians told me that I would ride for approximately three hours before we reached our final destination, known as the bush, an area visited by many while in Africa on safari.

As I boarded the small plane to Nanyuki, it was apparent that there were others there who had flown these parts of Africa before, just from listening to their conversations. As the single-engine aircraft started, a burst of adrenalin overcame me almost instantly, coating my body from the inside out, and fear was no longer an issue. We were welcomed with words from a young Kenyan pilot with a warm radiant smile. As he turned around completely to get a passenger count, our eyes locked. It made me feel somewhat special, because his eyes seemed to say, "Welcome home, my brother."

The small plane engine began to roar like a lion, and we proceeded to the runway, which was overtaken by a sea of grass that appeared to swallow up its outer edges. Within seconds, the plane started down the runway, the rough surface producing a rumbling sound from the quick-spinning aircraft tires, letting me know to fasten my seatbelt. As I looked out the window, I noticed that the airport was a museum for

old airplanes that were standing at attention and waiting to serve their country. I looked straight ahead as the plane chased toward the tail end of the runway, and I gripped the edge of my seat as the ground quickly disappeared from underneath us and the small plane started swaying from side to side.

Leaning to the side with my nose on the cold window made it a little easier for me to see the unbelievable aerial view of the massive congestion of the city. I saw children walking to school in their different-colored uniforms. My eyes then focused on the large number of commuters that jockeyed for position in the thick traffic as they traveled to their jobs. As I continued to look at the amazingly beautiful countryside, I began to weep. I strained to see through the clouds, toward a dense area that was quickly approaching. Today this part of the world has a large, ugly scar that stretches over its face. I witnessed the very poor conditions that had overtaken the city of Nairobi. It was hard for me to believe what I was seeing as the plane tilted to its side to give me a better view of the old, dilapidated makeshift homes with rusted tin tops; they were barely standing, leaning against one another for support. The loose, jagged boards used to patch up holes in some of the homes pointed to the sky, resembling hands that stretched toward the heavens, asking for help and relief from the painful living conditions. As we soared to greater heights, the beautiful white clouds did my sorrowful eyes a favor by removing the painful view I had witnessed miles below. The small plane became a prisoner of the heavens as we slid along the white sheets of ice in the sky. The smell of the air was very refreshing, and I had never smelled anything like it before.

While I was thinking about loved ones back home, the pilot announced that the drop-off point for the first set of passengers was coming up soon. There would be a total of three stops, with mine being the last. Not much longer after the pilot's announcement, we started our descent, and I looked for a landing strip. Within minutes, everything came into view, and a cleared-out area was used as a runway. As we approached, I grabbed the sides of my seat and held on for

dear life. This time, the runway was a bit rougher, with holes and washed-out spots, which produced knots in my stomach as I thought of what could happen. After the first group of passengers disembarked and good-byes were said, we took off again immediately. The second stop came and passed very quickly, and then it was time for my departure. As we approached the airport, its runway looked freshly built and a little more modern. As the plane landed, I could see, to my surprise, that there were travelers ending their safari adventures, while mine was just beginning.

After the ground crew secured the aircraft, the door slowly opened, and a set of built-in steps was eased to the ground, making it easy to exit the small plane. I was the only passenger to exit, and my feet hit the soil of Africa as I inhaled the clean scent of God's fresh rain. Gathering my luggage, I immediately zeroed in on my tour guide. As he started out toward me, he stared continuously, and the distance between the two of us slowly disappeared. Without asking my name, he kindly grabbed my duffle bag from my hand while smiling at the same time. His friendly smile swallowed his entire face as he introduced himself with a deep, rich accent. I couldn't believe that such a voice could be housed in a body that was so similar to my own. In just a short amount of time, our acquaintance developed into a fruitful friendship as we introduced ourselves to one another. Without asking his name, he said, "Lenjoh." The mild bass tone of his voice vibrated in my ears before I could give my name; it was the first time I had ever introduced myself without giving my name first.

"Thompson, how are you?" he asked.

I responded quickly, "Very fine, my friend."

We jumped into a land cruiser designed for safaris and immediately took to the streets of Nanyuki. After a few minutes of driving and seeing so many African people, young and old, walking along the side of the road, Lenjoh pulled off the road onto the shoulder and stopped the vehicle. He asked me, "Do you have any idea as to your location?"

I didn't want it to seem so funny, but I almost answered, "Africa." Since he was the host and I the guest, it would have been easier for him to give me the answer, because I hadn't the slightest idea. As I paid close attention to the area, the one important thing I did notice was the large cluster of people standing on both sides of the road. They were taking so many pictures that the camera flashes overcame the brightness of the afternoon sun.

Lenjoh knew I couldn't come up with an answer, so he tortured me for a while longer before sharing the answer. Once he exposed that incredible smile of his, I knew the answer was forthcoming. He said to me, "Look at how and where the people are standing." The people looked as if they were standing in some sort of line to purchase tickets for an unknown event. Without giving me the answer, he said to me, "Let's get out." We then walked over to join the international crowd of people. He finally gave me the answer. "You are now standing on the equator that separates Africa into two regions, northern and southern."

My eyes lit up so brightly that they could have been used in the sky, one for the sun during the day and the other for the moon by night. As a kid in school, I had read much about that special place, and I had never thought that someday the Lord would bless me so that I would be standing where I was that day—not just the equator, but especially Africa. We then took to the road once again, and our next stop was in the small town of Nanyuki, to buy supplies for camp and to fuel the truck for the two- to three-hour trip to where the campsite was hidden amid the bush and wildlife.

While fueling the truck, Lenjoh got out and vanished with some of his friends, which I didn't mind, because my hands began to tremble at the opportunity that was before me as I sat in the front seat of the four-by-four. My accommodations didn't allow me to get too comfortable, so I had to do a little twisting here and some turning there to capture the true reality of life as it passed in front of my camera lens.

As I continued taking more and more heart-stopping photographs, Lenjoh popped open the driver's side door, indicating that it was time

to move on. He informed me that I must be careful when taking pictures, because there are times when special permission was necessary when photographing certain African people or events, as they valued their traditions and culture. How had I forgotten so easily? I knew that photographing in some parts of Africa was prohibited and that there were instances where special permission was definitely required. Believe me, I knew all about the dos and don'ts from reading just before coming to Africa, but for some reason, I had let temptation overcome me. I realized that as a photographer, I must respect the privacy of others, and most importantly the laws of the land. I quickly lowered my camera and thanked him for his advice, because I knew that Lenjoh meant well and he cared about my welfare.

As we eased out of the small, congested town of Nanyuki, the paved road pointed us in the direction of our final destination. I continued to notice the many people walking for miles upon miles along the roadside, and I asked myself, *What if the characters and roles were to change?* The images before my very eyes reminded me of how truly blessed I had been.

When Lenjoh slowed down to turn off the smooth, paved road, I didn't expect what was about to hit me so fast. As we continued our journey down the red, dusty roads, the doorway opened to miles upon miles of bush, wildlife, and people in villages that time had forgotten.

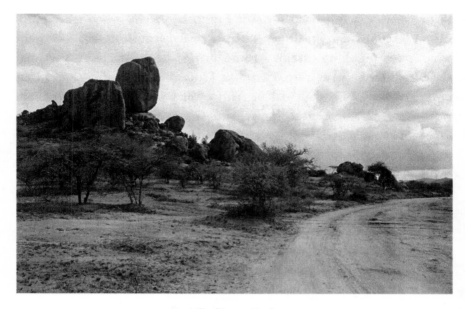

Hill of Large Rocks

My eyes feasted on the beautiful landscape, and Lenjoh was kind enough to stop several times to let me photograph scenes that I probably would never again see in a lifetime. As we continued on, the bush thickened, and I began to see different species of wildlife as they roamed over the countryside. As we got deeper into the bush, the roads began to get rougher. Lenjoh, an excellent driver, maneuvered the land cruiser slowly through the bush, like an ant searching desperately for food. Talking a little less to concentrate more on his driving, he pointed ahead to show me an area that opened my eyes wider than half-dollars. Off to the side of the road was an unbelievable scene where African elephants had carved out a pathway through the bush as they searched for food, leaving a highway of destruction as they stripped small, thorny trees of their bark and vacuumed the leaves from the fingertips of each limb.

We continued to make our way down the makeshift red dirt road that was highlighted by the low, bushy trees. I noticed that the sun had

reached its noonday resting place in the sky, and now it had started descending to seek shelter behind the beautiful mountains that waited patiently for its nightly visit. While I was reflecting on the movement of the sun, Lenjoh finally broke the good news that camp was only a few minutes away. After so many hours of flying and being held captive in my Sunday suit, I was ready to loosen up and meet with my new friends at camp.

For the past two years, I had been planning and dreaming of what it would be like to visit Africa, the one place that I had always wanted to see. I wanted to learn from what I experienced about the culture and the traditions of the African people that have been passed down from century to century. As I looked straight ahead, our campsite slowly came into view, and my blessing was about to finally become a reality. The Lord had answered my prayer of prayers because I waited patiently on him.

The cruiser made a final big bounce, then slowly came to a rest after a long day's journey. Never in my life had I pictured myself standing in the middle of an African safari camp. I had almost denied myself my lifetime dream, thinking that television was going to be the closest I would ever get to Africa. Now I realized that prayer, trust, and a little faith the size of a mustard seed, all rolled up into one, equaled a blessing from the Lord and would make anyone's dream, large or small, come true.

I got out of the land cruiser and searched the campsite with my tired, blurred eyes. I was stunned and amazed to see two tall figures that stopped what they were doing and started walking toward Lenjoh and me as we approached the main camping area. They were two Samburu warriors hired by Lenjoh; they were great cooks and trackers who had the ability to spot wildlife in the bush of Kenya. I'm not known for staring at anyone for long, but I could not take my eyes off them, because they were beautifully decorated in their full African attire. With only a few steps remaining and the gap slowly closing between us, I could get a closer look at their smiling faces, which hypnotized my

eyes and froze my footsteps almost immediately. My heart was capti-
vated by their kindness as the two greeted me with hearty handshakes.
To my surprise, they spoke very good English with a slight African
accent. Lenjoh now had the hard task of getting me to remember their
names for the next few days. He lined up his team one by one, starting
first with Losorogol, known as "Big Guy" for his tall stature; he once
was a warrior but was now known for his great tracking ability. My
acquired friends were Lokomoiro (Laikipia Masai), Tuwe (Nandi), and
Kura (Turkana). As indicated, all were from different tribes that made
up one of Africa's friendliest families. I was truly blessed and glad to
meet them.

James and Kerry Christian, the young owners of this safari com-
pany, had told me that Lenjoh would have a good staff of dedicated
men with him on safari. After our greetings, without any hesitation,
they removed my luggage and camera equipment to lighten the load, as
if I were violating camp policy. I couldn't believe what I was going to
experience over the next few days while on safari, because I began get-
ting the royal treatment right away. They led me over to a large open
tent with no sides, known as the "kitchen." The staff prepared food
and drinks for my arrival. As I sat down for my first African meal, I felt
a little out of place because of my dress attire. I was wearing a suit,
which made me look like a stop sign standing in the middle of a desert.
Lenjoh and the two staff members began speaking to each other in
their native tongue. After a hearty meal, I was shown my outdoor
accommodations, which consisted of a tent, a shower, and a potty
house. Believe it or not, each was capable of being moved and relocated
at a moment's notice. It had been many years since my tent days as a
Boy Scout while attending elementary school. My sleeping tent was
just the right size, because it allowed me to stand up and walk around
inside with no problem.

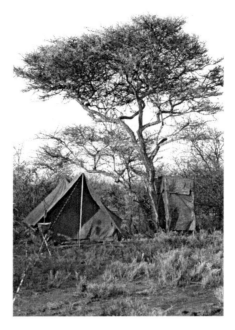

(Tent)

The twin-size bed was very well padded and had all the covers that I needed to get a comfortable night's sleep. The outdoor shower met all my specifications, as it came with a large water bag that was hung from a tree limb with the muscles of a body builder. Even though it didn't come with modern-day fixtures, it met all the requirements for an outdoor facility. Back in the old days, we used what was called an outhouse for a restroom, and being here brought back childhood memories of visiting my great grandparents in Huntsville, Texas during the summer. I can just imagine what today's youth would do or say if they had to experience that way of living.

I couldn't complain about my accommodations, because all the camp facilities that they provided were in excellent taste. Yes, I could have complained and expected more after traveling halfway around the world, but I didn't expect everything to be great. Besides, my accommodations could have been in a deplorable condition, and I actually

could be living like this one day. So that's why I came to realize how truly blessed that I was to have the little things that the Lord had blessed me with to meet my needs. *Thank you, Lord,* I thought.

It was now time for me to forget all about city life. I removed my suit and took a few steps toward living in the wild. After shopping like the average woman day after day back in the States, it was now time for me to strut my stuff by putting on my safari uniform for the first time. When I was fully dressed, I felt like a soldier getting ready for battle. Just looking at me could have fooled anyone into thinking I knew what I was doing, based on the way I was dressed. But in reality, I couldn't lead a group of elementary kids around a city block without getting lost.

As night slowly approached, I began to get a little hungry while sitting in my tent, and I wondering when dinner was going to be served. My previous meal had been just before checking out of the hotel—breakfast.

Lenjoh called my name loudly. "Thompson!" It was time to eat. I asked myself, *Was he reading my mind?* He called me over to the campfire, where a small table and chair stood waiting, as if I had made reservations. It was a great location for a camp, because it was right on the bank of a river, where the water was a beautiful, deep, sandy red. It was also apparent that the water was trying to escape the high banks of the river as it flowed rapidly, winding its way through the bush on that late night. I asked Lenjoh the reason for the high water level of the river. He replied kindly, "There have been heavy rains for the past few days before your arrival." I remembered that along the way, there had been a few showers as we made our journey to camp earlier that day. I looked up into the night sky; it was full of clouds rather than sparkling diamonds, warning us that there might be rain on the way.

Preparing myself for a wonderful dinner, I noticed that a new face had popped into camp without warning. A young warrior by the name of Happy brought dinner to me with a smile on his face that you could bottle and sell. Here in Africa, Leshapani was Happy's real Samburu

name; he was known for his good cooking. I thanked him kindly for dinner, which was quickly followed by a welcome from him. Our exchanges were so fast that it seemed as if we were talking at the same time.

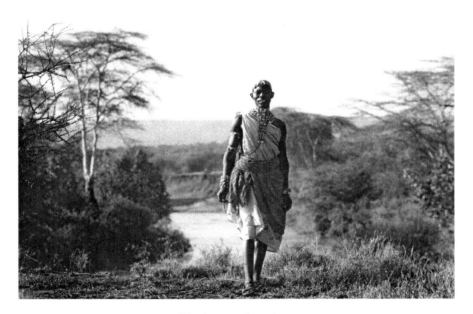

Warrior standing alone

It was obvious why the group called him Happy; I noticed his unbelievable smile and how his teeth sparkled against the evening moonlight. The flames from the campfire highlighted the richness of his dark skin. I knew immediately from his trademark smile that Happy would be a special friend to me while on safari. Even though he was short in stature and regardless of the conditions, I knew I wouldn't have a problem spotting that smile on his face anywhere. After putting my appetite on hold for my brief introduction to Happy, my hunger pangs resurfaced. As Lenjoh and I started to eat, drops of rain began to fall, so I started to eat a little faster. I noticed that it was nothing like I had eaten before. I had to tell myself to adjust, because fast food was out of the

question here in the bush. Just from noticing earlier that day what was for lunch, I could tell that fried food wasn't a part of their diet.

Suddenly the rain came, and we all made a mad dash to our tents. After an hour or so of resting and relaxing, I began to get a little sleepy. I was tired from a long flight and had just eaten a well-balanced meal, so it was easy for me to fall asleep. I was only asleep for a short period of time before I was awakened by loud voices coming from the kitchen area of the camp. The situation sounded tense and serious; all the voices flooded together as if on game day at a sporting event. I quickly jumped out of bed and ran out of my tent to see what was happening and to see if I could be of any assistance.

The damage was already done. I couldn't believe what had happened in such a short period of time! Rushing water from the rain had flooded the large tent that was known as the kitchen. I asked myself how such a large tent could almost be swept away, along with some of the supplies. Lenjoh walked over to me and with a calm, relaxed voice explained the fast-flowing water, which glided through the kitchen as if searching for food, taking what it needed, and later joining up with the river to make a quick getaway like a thief in the night. I began my own investigation, surveying the entire camp area for clues as to what might have caused the flooding. First I noticed that the ground seemed to be flat, which didn't seem like a good cause for the flooding. Then the answer came from Lenjoh. He explained to me that a slight incline in the ground over a long distance could cause rushing water at unbelievable speeds, even when the ground looks flat to the naked eye. I guess that was why I had seen so many deep trenches in the land, where the rainwater had taken out its anger on the dirt roads we traveled earlier that day, which made driving a little difficult for Lenjoh at times.

It was now bedtime, which was okay with me, so I started back to my tent. Lenjoh set the tone for the next day by letting me know about the 6:00 AM wake-up call. As I made my way back to the tent, rubbing my arms, I began to feel a little chilly, so I decided to sleep fully clothed on my first night in Africa. I wanted to get my money's worth

out of my safari gear. I finally eased into the bed and was swallowed by the thick covers as I lay on my back for a while, thinking about the next day. I listened for the first time to the different sounds of wild creatures as they communicated with one another throughout the night.

Second Day of Camp

The morning wake-up call was not made by Lenjoh; it was the beautiful singing of the morning choir of birds. They seemed to know that a new guest was in town, and they put on their best performance for me. Then suddenly the singing of the birds came to a halt as a second wake-up call was delivered in Happy's out-of-tune voice. He approached my tent and greeted me politely. "Good morning," he said.

"Good morning to you," I quickly responded.

"Thank you," he said. He then informed me that breakfast and my morning shower were prepared and waiting for me. I continued to lie in bed just a little longer with both hands underneath my head, staring at the top of the tent, wondering what the day's events were going to be like.

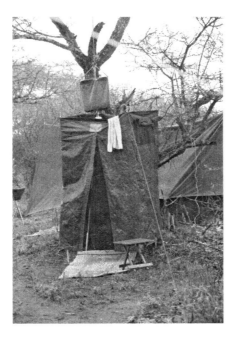

Shower tent

Quickly jumping out of bed, I made the short journey to the shower area, where I noticed a huge bag suspended from a large tree limb that was enclosed by a tent. Removing my clothing, I stepped inside from the cool morning air to take my shower. You could tell from the steaming bag that the water was well heated for comfort against the cool morning air. I opened the nozzle on the bag, and the warm water started its full attack on my skinny body. Catching some of the running water in my hands, I could tell instantly by looking at its coloration that the water had probably come from the river. It really didn't matter, because it was my first great shower taken outdoors. I hurried to finish, then I quickly made the return journey to my tent to prepare for an African breakfast. The smell of bacon beckoned me to the kitchen. Just before I started my first day ever on safari, I paused to pray and give thanks to my Lord and Savior, Jesus Christ. I kept telling

myself that if it weren't for Him, none of this would have been possible for me.

For some reason, Kerry and James, being the young owners of their own safari company in Kenya, were on my mind. Right at that particular moment, I was wishing they were with me so that I could let them know how much I appreciated what they had done for me. The couple had placed me in some of the best hands, namely Lenjoh, Mr. Happy, Kura, and Losorogol, and others I was not too familiar with at the time; their names I had yet to learn. Just being in camp for that small amount of time had created a strong bond among us.

As the aroma kept getting stronger, the smells of breakfast swarmed my tent like smoke from a burning house, forcing me out to the morning campfire. Once again, a small table and chair waited for my arrival, and I was soon joined by Happy, who made sure that breakfast was right on time. While I was looking over the breakfast table to select from the many choices, happy caught me off guard with a surprise greeting, interrupting my breakfast selection. I gathered a small pile of food on my plate so that I could make my way back to the warmth of the campfire that was still located next to the river.

While eating, I noticed that the swollen river had changed overnight, with calm and peacefully flowing red water that highlighted the beautiful, sweet-smelling morning. Last night, my mind had been held captive to the thought of having a rained-out safari trip. I wasn't going to worry about anything, because if it's the Lord's way, then it's my way too. I have come to realize that joy comes in the morning, and I will be waiting for that time to arrive.

As I continued to gaze into the red, flowing water of the river, Lenjoh showed up to join me for breakfast. We talked about the day's schedule of events, which excited me. He wanted to know if all the things he'd heard about Texas were true. Without going into detail and with a smile on my face, I let him know that some things he probably had heard were true, while others were not. I quickly stopped him before he could ask more questions, so I could thank him and the staff

for making me feel at home. There were several occasions when I felt a little guilty about the special treatment provided for me since stepping on African soil.

After the question-and-answer session fizzled out, Lenjoh seemed to be happy with my answers, as the smile on his face refused to leave. I hurried to finish my breakfast, which consisted of cereal, bacon, fruit, a little yogurt, and of course some of that strong African coffee—capable of knocking down a mule after a couple of swallows. Lenjoh rekindled our conversation, informing me that he would be leaving for a short time to check on a few things and that upon his return, the safari would begin. That sweet news immediately made me crack a smile, and it put joy in my heart.

After breakfast was over, I slowly made my way back to my tent to prepare myself for the afternoon trip. Before I could begin gathering all my equipment, Happy knocked on the door of my tent. Stretching my neck slowly, I stuck my head outside the tent's doorway to see his smiling face. He offered to take me on a short outing to scope out some game until Lenjoh returned for the main event of the day. Happy did me a great favor by offering this opportunity, because it would give me a little camera time in which to practice and make any adjustments that might be needed to capture some great photographs.

Gathering all the necessary camera equipment, I shouted, "Let's go!" and we were on our way. Before we left camp, Happy began to tell me that the land we were on belonged to the proud owners, Kerry and James, and consisted of a few thousand acres of bush and wildlife. I looked around to wave good-bye to the other members of the camp. Lenjoh was leaving camp as well to make arrangements for today's cultural tour to one of the local villages. There was a possibility that I might have a first chance to witness a live African wedding, which would truly be a great experience for me.

Things were starting to come together, and my dream of experiencing African culture was so exciting that it raised goose bumps all over my arms, as if measuring the coolness of the morning temperature. As

Happy and I slowly vanished from the campsite into the dense bush, the branches of the low-spreading trees resembled arms being wrapped around us, which made it look like we were being lured into the unknown. Without being asked, Happy volunteered to tell me of the many traditions of his people and what his tribe believed in and stood for.

As we moved deeper into the bush, it wasn't long before we spotted different species of beautiful birds. The thicker the bush, the slower we walked, because it was a little harder to see any movement of game; the bush was a source of cover and protection for the animals. It didn't seem to be a problem for Happy, as it was for me; this made me realize that these guys had exceptionally keen eyesight. I began to realize from little clues that my eyes were feeling the effects of age, because during our march through the bush, I had to use the lens of my camera as glasses to focus. I located a herd of impalas—well-dressed animals with beautiful coats of hair used as camouflage from the danger of predators and strangers. Happy easily convinced me that he had the tools to become a safari guide of the future, by his ability to spot game movement in the bush, regardless of how far or near any animal might be.

Continuing at a snail's pace, we slowed down to observe the various animals' tracks, and Happy had a name for each. Many of the fresh animal tracks were positive indications that wildlife could be nearby, so I had to be ready for a quick shot if necessary.

We turned off our original course, and Happy suggested that we try looking around the area of the river, where wildlife sometimes could be plentiful, as animals stopped to drink during their travels. It just so happened that as we arrived, Happy instantly spotted a group of monkeys sitting on the riverbank grooming one another, as if preparing each other for an upcoming banana festival.

As we continued to walk along the banks of the river, there were other signs that wildlife had paid a visit to the river during the night, for fear of danger during the daylight hours. With my camera in position, I slowly scanned the horizon for any wildlife activity, and without

paying close attention to where I was going, I almost walked on top of Happy as he knelt to examine a set of unusual footprints left by a night creature. These particular tracks apparently were of some interest to him, because out of all the tracks that we had seen so far, these seemed to be a little more special. Silence finally released its grip on his lips as he tried his best to clearly describe the night visitor. At times I couldn't understand him because of his strong African accent, so he immediately took to the dirt and displayed his artistic skills on a cleared area of the ground.

Getting up from my knees to give him more room, I began to look around to see if camp was in walking distance. As I stood towering over Happy while he continued to draw, I was amazed as the picture began to take shape, seeming to come alive. I thought to myself, *If he can draw this well on the ground with a stick in his hand, I wonder what the picture would be like if pen and paper were accessible to him.* The picture of the animal seemed as real as the late morning air blowing over the carving in the red, sandy ground, as if trying to give life to the figure's body. I quickly stood back for a series of photographs as he finally put his final touches on the picture that resembled an anteater.

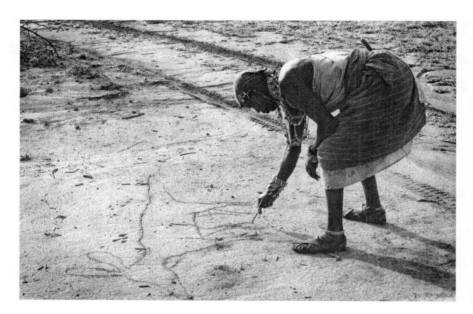

Warrior drawing on ground

As we moved on in the direction of camp, Happy began to sing some old African hymns that he had learned as a young boy. I listened closely to the words, hoping that I could pick up a tune or two. Without asking, I joined in, and he looked at me with that patient smile on his face. At one point, we even stopped walking so that he could help me learn the words in the song, as I tried vigorously to inject that smooth African accent into my voice. It was a hopeless case for me, as my throat sprung a leak, forcing out a crackling tone that made me ask him if it would be okay if I hummed backup while he sang. It came as no surprise when he quickly agreed, with an even larger smile on his face.

Once again, we seemed to veer off our pathway to the campsite. All of a sudden, I realized why the camp kitchen had flooded the way it did the day before. There were many areas where the rain had washed out the grounds, as if it were constructing its own highway through the bush, leading directly downhill toward our camping area. In some

places, I could see how the rainwater had carved out trenches as much as a foot deep and maybe a couple feet in width, like easing a knife into a cake. On this first day that I was introduced to the bush, it was clear in my mind that there were going to be no smooth roads. On the previous day, we had been bounced up and down like lottery balls as we darted through the small scatter of trees as if going through an obstacle course, heading for camp. There were several times when I felt like telling Lenjoh, "Hey, let's get out and just walk the remainder of the way." I must admit that city life was still flowing in my blood somewhat, but a couple more days under my belt in these conditions would definitely leave me no choice but to get used to what I would face. On this short trip with Happy, my body let me know that I had been a little lazy in my daily workouts back home, because walking over these grounds was like working out in a local gym. My brother Charlie, a personal trainer in Houston, would have killed me if he had known the shape I was in before making this trip.

It was so amazing for me to stand there and see how beautiful the vast terrain looked to the human eye, but I could also see how it could be deadly when trying to conquer it by foot. Walking up a short incline for a few minutes in any direction revealed an unbelievable view of miles upon miles of colorful mountains, standing shoulder to shoulder in the horizon as if creating a design for a death-defying roller-coaster ride. On the other hand, the design of the land could produce a downward motion of descent, making it seem as if the ground was sloping to its knees, limiting one's view to only a face-to-face picture of thorny limbs protruding from the small, bushy trees.

I asked Happy why we hadn't seen more wildlife. He immediately let me know that as the temperature during the day starts to get warmer, most animals seek shelter in what little shaded areas they can find to use as cover from the hot sun.

Pushing a little further into the bush, but keeping close to camp, the red dirt roads played a significant role in the bush, as they moved like serpents over the hundred miles of barren land. With my poor sense of

direction, it was hard for me to figure out how anyone could remember their way in or out of this type of forest as they searched for their final destination.

The time had come to change our course once again, in order to get back to camp before Lenjoh arrived. If this was a simple test of a safari, I couldn't imagine what the real deal was going to be like the next day. After walking for a few minutes longer, and just before knocking on the door of camp, I noticed Happy suddenly stop. By instinct, I grabbed my camera from my side as Happy signaled me to come closer to him. He pointed in slow motion to a bushy area, where my eyes zeroed in on another sighting of African wildlife; a pair of Kirk's Dik-diks, lodging in the shade away from the warm rays of the sun. These small, beautiful deer-like animals have very tiny heads that seem to be too small for their bodies. As I eased up my camera into position to shoot, they quickly disappeared into the bush, and I was left without any hope of getting a single photo of the husband-and-wife team. Happy smiled at me and said, "You have to be quick."

I smiled back and replied, "I see, my friend."

Just as we were about to exit the last wall of bush, we could hear the engine of the land cruiser make its last roar, indicating that Lenjoh was also returning to camp. As we emerged into the clearing, I could see Lenjoh looking our way as he was talking to the other members of his staff. I thanked Happy for the guided tour and for going out of his way to ensure that my trip was off to a successful start. Our acquaintance had solidified, quickly producing an unforgettable bond between the two of us in just a short period of time.

When we arrived at camp, Lenjoh called my name almost immediately. "Thompson, here is the plan," he said. With a wide, open smile on his face, he said, "Thompson, I want you to see firsthand how the African people retrieve honey from the honey tree."

I was a little confused. I had to ask myself, *What honey tree?* The smile on his face became even larger when he noticed my eyes begin to search the surrounding area for any bee activity. Seeing that I couldn't

find what I was looking for, Lenjoh pointed to a particular tree, called the yellow fever tree—named, I suppose, for its beautiful yellow color. The yellow bark on this tree looked as if it had been hand-painted by Mother Nature herself. It stood very tall just a short distance away from our campsite on the bank of the river. It leaned toward the open sky, smiling as if it were holding a conversation with heaven, while its long, skinny branches extended outward, giving it the appearance of waiting to receive a special blessing from the Lord.

I was amazed by the long tube-like containers that hung from various branches of the tree. I couldn't figure out what they really were. Lenjoh informed me that they were old, hollowed-out logs, capped on both ends, used as homes for the bees. Shaking my head in disbelief, I found myself once again having an inner conversation. *You learn something new every day,* I thought. Back home, I was accustomed to seeing the large, white boxes sitting on the ground in the Texas fields, used as homes for the bees. Without questioning Lenjoh, I asked myself, assuming I knew how the honey was going to make it from the tree to the taste buds in my mouth. While I looked at the tree, puzzling over the situation, Lenjoh and the others were in a group session a short distance away from me, preventing me from hearing the topic of discussion that was so important to them.

In a high-pitched voice, Lenjoh called me over and let me in on a little secret. He made a sweet suggestion that we take another short walking safari in the bush, this time in the opposite direction of Happy's guided tour that I took earlier that morning. Lenjoh's reason for another guided tour into the bush was to spot, track, and identify game, while allowing Mr. Happy to prepare himself for an adventure to retrieve some goodies from the beehives—the honey roundup.

I could tell from the start that the second march through the bush was going to be a little different from the first one with Mr. Happy. This time my guides would be Lenjoh and another member of his staff—the tallest of all. Any one of the warriors of the Masai tribe could

have acted as a guide on this trip, but for some reason, Lenjoh chose this very tall, gentle giant to go along with us.

As we started on our way, I brought up the rear so that I could be in position to take advantage of any photo opportunity that became available to me. Sniffing our way through the bush, I couldn't help but keep my eyes on the tall, skinny Masai guide as he towered over the low-spreading bush as if playing flag football with first-graders. I really was fascinated by the clothing he wore, as it showed the history of the Laikipia Masai tribe.

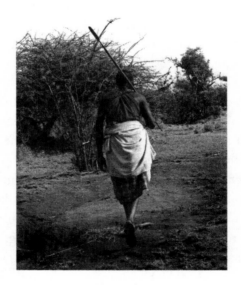

The tracker

The royal-blue sky used the brightness of the sun as a stage spotlight to highlight the Laikipia Masai traditional way of dressing, consisting of a full-length skirt and a wrap over one shoulder, which was secured by another wrap around his waist. As we continued to stroll through the bush, I continued to observe the magnificent, bright-red tribal

clothing. The hot rays of the sun pressed the beautiful color against his dark skin as he walked on the hard, red soil of Africa as if modeling and using the wildlife for his audience. He carried a special spear with a sharp blade that stood for protection, and its length symbolized long-lasting peace.

After walking for some time and not spotting any game, we did notice some animal tracks: the only evidence that wildlife had been in the area at one time or another. Moving and stopping on several occasions, we began to spot more tracks of different species of game, and Lenjoh schooled me by naming each one, as Mr. Happy had done. After the day's two sessions with Happy and Lenjoh, I could tell that getting the right feeling for wildlife safari was not going to take me long. It was a great way for me to get my feet wet, gaining some experience before the real deal started the next day. As a matter of fact, my main concern was not about being on a safari. I wanted to stay focused, explore, and gain as much knowledge as I could in the little time allowed—to receive and learn about the culture of these wonderful, beautiful people.

I noticed the spear on the Samburu guide's shoulder as he continued his tracking. Lenjoh and I dropped a little distance behind, discussing his people's way of life. One thing I quickly picked up regarding the people of Africa was that their main method of transportation in the bush was by foot. Lenjoh let me know that the African people walked for miles and miles for many important necessities, such as food and water. But they had to be cautious when they selected their times for traveling; during the day or perhaps the evening hours were best because of rare elephant attacks, which had been known to happen during other times. Lenjoh told me that many people each year were killed in these attacks, and now I understood why a guide always carries his weapon of protection. The long spear with its large blade could bring down an elephant without any problem, if entered into the body correctly.

It was good to see Lenjoh open up to me a little more as the two of us continued to walk and talk more about Africa. He let me know that I could ask him anything about this world he lived in, and this was very comforting to me. It made me feel warm inside that he was willing and able to make my trip a success. It wasn't because I was a tourist on safari or it was his job; I could tell that it meant so much to him to discuss the beauty of his country and the traditions that have made it what it is today. Discussing wildlife safaris with Lenjoh was one thing, but if I wanted to see his smiling face change to a serious look of concern, I let Africa be the main topic of discussion. It was good to know that he wanted me to feel like I was a part of the African family, as we spoke brother to brother.

While we were deep in our one-on-one conversation, all of a sudden the Samburu guide stopped and pointed across the river. "There," he said quietly.

"What?" I asked softly.

"Impala!" he replied.

All in one fluid motion, without hesitating, my camera went to work as if it had a mind of its own, firing four to five frames and capturing the subjects in their tracks. It felt great when my adrenal glands kicked in, producing a burst of energy that flowed throughout my entire body. After taking these exciting photos, I thought about the amazing eyesight of the Samburu guide. Had this herd of gorgeous animals not moved, I wouldn't have noticed them feeding, because of their beautiful coats of hair that perfectly blended in with the red, sandy ground. As we moved in for a closer look, I realized how it was such a blessing to stand and walk among so many beautiful animals, knowing that they have as much right as we do when entering into their world of freedom.

As we continued on our journey, the river once again popped into view. We made our way to the bank's edge to seek animal tracks. The river dared us to cross, but fearing what might lurk beneath the surface of the flowing red carpet of rushing water, we decided to walk slowly

along the riverbank, hoping to see evidence of fresh tracks. Lenjoh quickly spotted several different kinds of tracks of game that might have come to drink the day before, which he could tell from looking at the freshness of the footprints.

We continued to follow the twisting river as it flowed through the bush like a racecar going into a deep curve. We walked along, following one another as if playing the old childhood game of Follow the Leader. Then the tall tracker stopped, his eyes open wider than I'd ever seen them as he stared at the ground without moving. Lenjoh joined his friend to perform his own personal investigation of the eye-catching animal tracks, possibly made the night before.

Lenjoh slightly raised his voice as he asked me to come over to where they were standing. *Boy,* I said to myself, *what's wrong now?* I wanted to know exactly what was so serious about these tracks, as opposed to all the others that we had seen. I got an answer that I wasn't expecting, one that caused my eardrums to vibrate from the tone of his voice; my heart skipped a beat.

"Leopard tracks," Lenjoh told me.

My next question to Lenjoh was going to determine if I was staying in Africa or packing up and returning home to the States. I respectfully asked him if he thought the cat would try to venture in closer or possibly come into camp. I noticed the seriousness on Lenjoh's face slowly disappear into a smile, and I had some idea what his answer was going to be. He said simply, "He wouldn't do that." Immediately following Lenjoh's answer, a fresh breeze kissed my hot, sweaty face. I was now brave enough to kneel down on one knee to get a closer look. I carefully touched the footprints of one of Africa's most dangerous predators of man and wildlife.

Lenjoh suggested that we move on. As I was getting up, I couldn't help but notice the tall skyscraper of a man looking down on me. His head seemed to be touching the white clouds in the deep blue sky. As I struggled with my old legs to get back on my feet, the guide quickly turned and headed back in the direction of camp. Lenjoh brought it to

my attention that the men back at camp should be ready to gather the honey, as planned this morning. Our departure from the leopard's playground wasn't soon enough.

As we began to walk slowly through the bush, I thought about tomorrow's big day, which would feature my first tour of an African village. After watching so many travel programs and wildlife shows on television, reality was beginning to penetrate my mind and settle in, and I realized that my first cultural experience with an African tribe was about to come true. As I looked up to give thanks to the Lord, the sun's rays kissed my face as if to say, "You are welcome, my child."

So far I was surprised by the temperatures here in Africa, because I had been expecting it to be a lot hotter during this portion of the afternoon walk through the bush, but the sun attempted to chase off what coolness remained in the morning air.

Destroyed trees

As I looked ahead into the far distance, I could tell that the Samburu guide was about to lead us into an area about the size of a football field, where it looked as if a Texas tornado had just landed and taken its vengeance on the land. I asked Lenjoh what could devastate such an area. He looked at me as if fearing that if he told me, I probably wouldn't want to continue our search for more game. I couldn't believe how some of the trees looked as if they had been pulled out of the ground surgically, while others were split in two.

Lenjoh delivered the answer that my anxious ears had waited long to hear. He announced that elephants were the guilty party. The small, thorny trees were no match for elephants and were eaten for lunch, even though some of the trees had sharp thorns an inch in length or longer. Nothing could stop this large land animal from satisfying its appetite, which carried over from day to day. It was amazing to see. In some cases, trees had been ripped of their bark, like peeled bananas. Shaking my head in disbelief, I stared at the horrible picture. I closed my eyes and tried to imagine how the limbs of these trees had been sucked dry of their leaves by the giant vacuums of the elephant's trunks. It seemed obvious to me that Lenjoh and the guide weren't that amazed; they were accustomed to seeing this type of nature destruction. Nevertheless, I had to march into the war zone to get a better look, and I reached for my camera to take several photographs of innocent trees that had suffered so much punishment for their participation in the beautification of Africa. The deaths of these trees seemed to take a little life out of me, so I turned around and made my way back to my African friends, who waited patiently for me. We departed the area slowly. The wind began to pick up, not for the purpose of cooling off the day, as it began to get warmer. The wind carried the voices of the trees, thanking me for visiting their dying world.

"Thompson," Lenjoh said. It seemed to be a favorite phrase of his. He wanted to know how I felt about today's walking safari so far, and he asked if I was getting ready for more exciting things that were yet to come. I let him know that everything had been beautiful and more

than I expected. I thanked him, along with the Samburu guide, for an exciting day. Lenjoh translated my thanks for his friend, who smiled back at me and nodded his head, following this with his best way of saying thank you. Throughout the daylong trip, I had noticed that the guide had very little to say, unless spoken to by Lenjoh, or if he spotted wildlife or tracks. Even then, he would speak to Lenjoh in only their native tongue.

Every minute of today's first trip in the bush had been an inspiration. I had learned about Africa, not only from the wildlife side of things, but also from observing the staff and how they went about doing things, from cooking to sharing duties with each other in and around the campsite. At the rear of the three-man convoy, I'd had a particular question all day that I wanted to ask Lenjoh without embarrassing him. The itch inside of me became stronger and stronger until I had no choice but to break my silence for the last time.

I picked up my pace to join the other two, who were having a one-on-one African conversation, and without hesitating, I quickly asked Lenjoh why there were so many harassing flies throughout the bush. Well, just as he was about to answer, a large number of unwanted visitors draped over us, asking, "What type of cologne are you wearing, my friend?" Quickly, I began to fan off what seemed to be hundreds of flies, but they toyed with me until I realized it was a losing battle.

I continued to ask about the group of pesky flying creatures as Lenjoh and the guide stood back with smiles on their faces. Lenjoh told me, "You're invading their territory and interrupting their lunchtime." I quickly looked around to see if there was a carcass in the area, but there wasn't one to be found. If something was dead here, a foul odor would be circulating in the air, not only attracting African flies but other animals as well, jumping at the opportunity for a free meal to cure their appetites.

"Here's what you should be looking for, Thompson." Lenjoh pointed one long finger toward a mound on the ground. It looked like a small mountain of bowling balls. "It's elephant droppings," he said,

and we all smiled while fighting back flies. All day long I had been noticing the large objects, but I hadn't realized that they were scattered mounds of elephant droppings; they looked as if they had been strategically placed throughout the bush. This was what had attracted the African flies. I now understand that when visiting Africa, especially while on safari, one must respect all wildlife, whatever shape or size—and as a matter of fact, all the way down to an annoying fly.

Lenjoh signaled to his man that it was time to head back to camp, and I agreed wholeheartedly because of my experience with the angry African flies. This was a warning to me that violators of their territory could be assaulted by a few thousand flies at a moment's notice. From heart-stopping leopard tracks to engaging in war with angry African flies—these two encounters alone made me wonder what else I might witness or experience in this unpredictable and untamed land of Africa, as it unveiled the secrets of its soul hidden within the depths of the bush.

As the day got longer and hotter, wear and tear was beginning to take its toll on my out-of-shape body. Rest was out of the question, because I was determined not to hold up the others. I hadn't shot any photos for some time, because there was no wildlife to be seen. My next option was to capture some of the beautiful landscape on film. The mountains surrounded us in all directions, giving the impression of holding us hostage. I vaguely remembered James and Kerry telling me that Kiruman, this particular area of East Africa, is known as the home of the Samburu people, and that there was a safari set up for me to visit one of the villages, to experience the culture and traditional lifestyle of these people as they went about their daily way of living.

I wanted to get a little more information about tomorrow's safari, but Lenjoh was involved in a busy talking session with his guide, and my understanding of what was being said was limited. I wished that I was capable of speaking their language, because without any doubt, it would have played a significant role when it came to communicating not only with Lenjoh, but with other people as well. As a young stu-

dent, I'd had my chance to learn a foreign language, but I had chosen not to. For this very reason, schools today shouldn't give students the option; learning a new language should be mandatory, because time has brought about a change. I will tell any student today that learning another language will help bring down communication barriers among all ethnic groups of people around the world. We, the people of today, should welcome new languages into our homes, so that our children of tomorrow can start from an early age, learning to become world leaders as translators, not just for the different cultures of people, but for the Lord. They can experience something special from other countries around the world. Even though I couldn't speak the language of Lenjoh's land, I thanked him when he would sometimes stop in the middle of a conversation with his guide to let me know what was being said and to tell me that I wasn't purposely being omitted from their conversation.

After walking for some time, our campsite came into view, and I saw my friend Happy and the others waiting for our arrival. Easing into camp, I noticed a few more new faces in addition to the staff, followed by one of Happy's famous patient smiles. He stood waiting for a return-to-camp handshake, and he quickly caught my attention with his unusual mode of dress. It was a little different from what he'd been wearing when we left camp earlier that day. Now he was dressed to kill in what he called his "garments of protection from bees." I had nearly forgotten that there would be a honey roundup upon our return to camp.

Even though fatigue had settled in my tired body, I quickly made a nonstop flight to my tent to replenish my supply of film for more photographs. Quickly returning to where all the action was going to take place, I took a few good, deep breaths to prepare myself for a relaxing photo session, even though my body was aching with pain from head to toe from walking all day—and there was yet more safari planned for later that day. This would probably be the only time I would have a

chance to photograph an African event of this kind, so I just ignored what my body was trying to tell me.

Just before the honey roundup was about to begin, I desperately tried to find a good location and a comfortable position before Happy emerged from his group of supporters, led by Lenjoh himself. Before Happy made his climb up the tree to the bee homes, the other staff members cheered him on, the old African way. I noticed that Happy's so-called bee protection gear had a number of gaping holes in it; this might invite any number of bees inside his clothing to kindly announce themselves with unwelcome stings—a sweet price for taking their honey. I wanted to warn him about the gaping holes in his clothing, but I guess it really didn't matter, because no one else was showing any concern.

I told Happy to be very careful. He turned and started walking toward the gorgeous, yellow tree. It stood firmly next to the riverbank, tilted slightly backward as if its branches were reaching out to hold the sun. Its deep roots pierced through the ground into the river, supplying a drink for its thirsty branches. Just before he grabbed hold of the tree, Happy yelled, "Let's go!" As usual, his traditional smile followed. He made it look like a work of art as he deftly made his way up the tree with his climbing equipment, which consisted of a long leather rope made of lion skin, a soft leather bucket, and a small bundle of wood secured with a string of vine; this burned very slowly, and they called it "smoking wood."

As he got within reaching distance, Happy began to fan one of his hands back and forth, indicating that the bees had started their assault on the unwanted visitor, trying to protect what they had worked so hard for, and now the sweetness of their labor was about to have a bitter ending. Happy was not to be outdone by the bees, and he slowly maneuvered his way through the barbed-wire branches until he finally reached one of the beehives. Quickly, before the bees could overtake him, he pulled out his smoking wood and inserted it into what seemed to be a hollowed-out log hanging in the tree; this was used by the bees

as their honey-producing headquarters. As the smoke overcame the relentless bees, they finally had no choice but to surrender not only their home, but also their prize possession. The gang watching from the ground held their cheers until Happy gave the signal by licking his fingers, and that smile of his gleamed through the tree branches like a sparkling diamond.

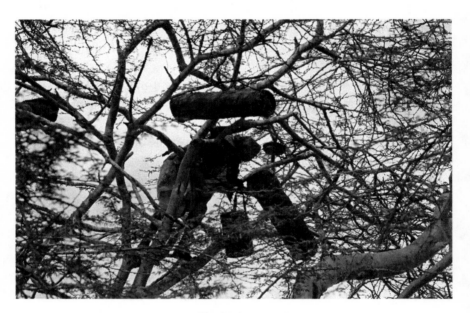

Warrior in tree

The people on the ground cheered in approval of a job well done. Without any hesitation, Happy moved along the branches once more to other hives and repeated the process. This time my 35mm camera was firing on all cylinders, and rolls of film popped out of my camera like bullet casings hitting the ground. Taking the leather rope made of lion skin, he looped it around other branches as he made his way in minutes to the front doors of other bee homes. He didn't knock, and they were taken by surprise; in some cases, there was no battle at all from the bees. It was amazing—I couldn't believe what I was seeing.

Happy never used any gloves, and he had no hand protection whatsoever. He only used his bare hands to reach into the hives to retrieve the honeycombs.

Keeping my eyes on Happy, I paused for a minute to thank God for blessing me and letting me be here to witness something I'd never thought I would see in this lifetime. In just the short time I had been here, my heart had been touched by Lenjoh and the other guys, who had done a marvelous job, working so hard to make me happy. Believe me, I was enjoying myself to the fullest while in Africa.

Lenjoh gave Happy the sign that he had gathered enough honey, and before I knew it, Happy had looped the leather rope around a branch for support and started lowering himself to the ground. Once again, he made it look so easy. Lenjoh and I, along with the rest of the guys, waited for the day's hero as he slowly lowered himself and the prize to the ground. Finally, Happy had returned to earth, and it was a done deal. Happy was the man of the hour.

Warrior with red hood

As we all huddled around Happy, Lenjoh said to me, "See how it's done, Thompson?"

I replied, "Yes, sir, my friend. Yes, sir."

While Happy was distributing the honeycombs, Lenjoh went on to tell me that honey was very important to the tribes of Africa, because it is a way of producing income for a village or an individual. After Happy made his final handout to his friends, he passed Lenjoh his piece of the honey pie, and he personally saved me a large piece of the honeycomb before it was all gobbled up. I felt a little guilty for getting the largest piece, because I hadn't done any of the hard work to deserve such a large portion. As he transferred the thick, glue-like substance from his hands to mine, I noticed the slow motion of the honey as it crept between his scarred and swollen fingers, which made him look as if he had been in the battle of his life.

I wasted no time before snapping off a small piece and transferring it into my waiting mouth. The taste was unbelievably delicious. As I looked around, all I could see were fingers popping in and out of so many mouths. It was an early Christmas present for my taste buds, as the honey was so thick and rich with sweetness. I had tasted honey that was store-bought, but there was no comparison to what came straight from Mother Nature's grocery store. Before I knew it, the large piece of honeycomb was the size of cough drop, and I wanted more. It disappeared just as quickly, and I licked my fingers to get every drop. I didn't allow myself to feel too bad for licking my fingers, because I could see that the others, including Lenjoh, were also licking the honey from their fingers. It was a great experience for me to see how the African people used what little they had to survive. They are truly happy people, whereas we fail to remember at times how truly God has blessed us with so much, and we still complain about not having some of the things we want in life. Already, I find myself just as guilty as others.

"Thompson!" Lenjoh called loudly. "It's time to go now to the village."

My heart started to thump hard immediately. Quickly I ran to get more film for my camera. I didn't want to miss anything. Before I had left home for Africa, I had prayed to the Lord, asking him to help me take the best photographs possible.

I moved quickly to the land cruiser and was about to get in when Lenjoh called my name again. "Thompson! Wrong side."

The excitement from this first cultural safari was getting to me, and Lenjoh knew that. The steering columns on these vehicles were on the opposite side compared to our automobiles back in the States. I just couldn't get used to it. But once were seated, we started on our way. Lenjoh had left camp early before I awakened that morning to make arrangements for my visit to the Laikipia Masai village that day, and for another cultural safari for the following day.

As we traveled the roads through the bush, it was like I was being shaken by my mother's hands for doing something wrong as a child. As we rocked back and forth, Lenjoh spotted a group of Thomson's gazelles running off to the side of the vehicle. The colors of these slender animals were so beautiful that they appeared to have on fresh coats of paint, and at first I failed to notice them in the bush. I can say without a doubt that Lenjoh had excellent vision; he was able to spot these unexpected sights even while he was driving. Happy, who also was riding in back, spotted some Grevy's zebras off to the opposite side of the vehicle.

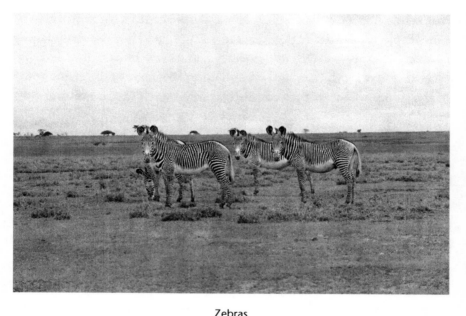

Zebras

Lenjoh said that these zebras were not plain, everyday zebras; they were of a different breed. I asked, "Why are they so different?"

He said, "Look at the stripes. They are a lot thinner than the plain zebra's stripes." I had thought all zebra's stripes were the same. He said to me, "I'll show you later, and you will see."

"Okay," I said. I slowly eased my camera into position and snapped several sure shots. It seemed that they were ready to pose for me without my asking.

As we continued traveling slowly on the twisting, winding, red dirt roads through the bush, a large mountain stared us in the faces as if asking us to stop before proceeding. The large pieces of rocks that made up the mountain were similar to granite. As we approached the mountain, Lenjoh stopped the cruiser. "There!" Lenjoh shouted.

A leopard turtle slowly moved toward us as if it was dying of thirst. It had spots just like a leopard and looked as if it could have weighed at least thirty pounds. The turtle didn't mind us at all; it just continued to move on. This was probably going to be one of the easiest photos I would take on this trip.

Lenjoh turned and stared at the mountain, looking up and down for a few seconds, which led me to guess what he was going to say next. *Please don't,* I was saying to myself. I guess he knew what I was thinking, and before I knew it, we started walking toward the mountain to make the climb. He said to me, "You're not going to believe the sight you are about to see, Thompson."

Happy took the lead, followed by Lenjoh. I was third and slow at that, because I was in no rush. I let them move far ahead of me, because I wanted to take some photos of them climbing. As I focused on them, I could tell that they'd made this climb many times in the past.

Lenjoh looked around to check to see if I was all right, and he noticed that I was in picture-taking mode. "Come on up," he said. "Thompson, this is the best place to take photos." His language was easy to understand, and his sentences were short. His accent was a little British.

As Happy made it to the top of the mountain, I could see that smile of his from well below. The young warrior stood proudly as he surveyed the miles of open land. Then Lenjoh joined him, immediately raising his binoculars to check for any movement of wildlife.

As I slowly looked for flat rocks to step on, I continued to look back and down to see how high I had climbed. The land cruiser looked like a kid's play toy from where I was standing. And then I completely turned around to witness God's creation. The sight took my breath away for a few seconds. I knew that I needed to get a little higher. I was just a few yards from being on the top of the mountain with Lenjoh and Happy. I had my camera in one hand, and I held onto the rock with my other hand. As I got closer to the top of the mountain, I had to stop, disappointed, because of the footing. I told Lenjoh that it was best that we stopped, and he understood. Even though I wasn't completely at the top, the view was unbelievable. I could see for miles and miles. With the mountain at my back, I couldn't see 360 degrees like Lenjoh and Happy, but my view was just as good. I took a roll of film in no time.

I could feel the temperature changing, but I didn't care, because this was a lifetime chance for me to see and to tell others about the people and the land of Africa. I'd had just a little taste of culture from the residents of Kenya, and I could only imagine what lay ahead for me in the days to come.

As Lenjoh and Happy stood up, I tried to position myself to continue the climb to the top of the mountain; however, a burst of wind overcame me, supplying a cool shield of protection against the sun's rays. I couldn't go any farther, so I headed back down toward the ground. Then I saw something move in the corner of my eye. I turned slightly to my right, and there stood a rabbit-like creature, staring directly at me. It began to make high-pitched noises, which signaled its buddies to come out. So I went down the mountain quickly before looking back to ask Lenjoh what it was. When he noticed what I was looking at, he called it a rock hyrax—an animal similar to a rabbit, but with no tail.

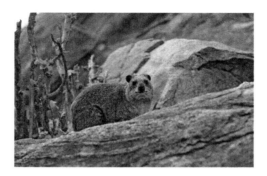

Rabbit like animal

Lizard

This little fellow deserved to have a photograph of his own in my photo journal. After the amazing photograph, to my surprise, one of Kenya's most colorful lizards, the agama, appeared out of nowhere. As the creature moved from between the rocks, the afternoon sun's rays bounced off its colors, making the reptile even more beautiful and deserving to have its picture captured on film.

My visit with my newfound friends was short, as it was time to move on to our next destination. Once we all were on ground level, we headed for the land cruiser to continue the trip to the Laikipia Masai village. It was time once again to meet the roughness of the red roads of Africa.

As Lenjoh started the vehicle, I asked him why he wanted to be a safari guide. He mentioned a past job at which he'd worked hard for over sixteen years, but being a wildlife guide had always been in his heart. Kerry, born in Africa, and James Christian, an American, had met, married, and joined forces in the safari business. The two named the business after the Karisia Mountains in East Africa. Karisia Limited was now Lenjoh's home, and he spoke of it proudly. I could tell instantly that he was proud of his job and the wonderful people he worked for, because his snow-white teeth quickly appeared in a large grin, illuminating his face like Christmas tree lights. He knew that he was truly a blessed man, and someday he planned to become a cowboy. I told him that Texas was the home of the cowboys and that he would fall in love with the Lone Star State. A cowboy hat, jeans, and—not to forget—those pointed boots were what he had always dreamed of having. He told me that he loved watching cowboy movies on television. *Cowboy movies,* I said to myself. I couldn't remember the last time I saw a western on the tube.

As we drove farther down the red-carpeted road, I noticed that there were herds of goats, sheep, and cattle being tended by young boys. Sometimes even young girls searched for greener pastures among the dry land that was flooded with rocks, as they searched for food for their animals. This was a daily job for a young kid in Africa, from sunup to sundown in the blistering sun. They walked for miles upon miles, looking for green vegetation for the animals for whom they cared so much. If only the kids back home could see what I was seeing, I think they would realize how truly blessed they are. No wages came with this job; it was a matter of survival.

Lenjoh started to speak in his native tongue, and Happy answered almost immediately. My one-on-one conversation with Lenjoh had almost made me forget that Happy was riding with us as we bounced up and down the rough roads taking us to our next stop. It seemed that we weren't in any rush to get to the village, because Lenjoh wanted to show me one of the local schools that he was involved with.

As we stopped and got out of the vehicle, dust quickly overtook us. I had to cover my camera for fear of dust getting on my lens. Happy stayed back as Lenjoh and I started the short walk across the field of dry vegetation and flies that continued to be a nuisance all day long. No matter where you went, they were there, waiting for you. As the heavy dust began to clear, I barely could see the small figures approaching us like little hunters. Lenjoh began to speak, and children's voices rang out with joy. When the dust cleared completely, I couldn't believe what stood before me, and my heart began to flood with sorrow and tears. The dirty, barefoot children quickly surrounded me as if I were Santa at Christmas time. They grabbed me by the hand, and I began to exchange small, gentlemanly handshakes with them.

Some of them played as we crossed the school grounds, while others didn't pay any attention at all to us. One child walked toward me with a half-deflated soccer ball that he dropped on the ground and kicked at me. I quickly shifted my camera to my right side and kicked it back to him. The smiles on the children's faces made me feel like a father to all of them. I walked quickly to rejoin Lenjoh, who showed me inside the small, windowless classroom made of bricks. He told me that he helped volunteers from other countries to build schools and churches in all areas of Africa.

I looked at the old wooden school desks, and then I turned and looked outside, only to notice that there were more children than desks inside the one-room school. There wasn't even enough room for a teacher's desk. There were a few pictures and hand-colored paintings on the wall to give the classroom a school spirit. The floors were as dusty as the roads we traveled on through the bush. I couldn't imagine how so many children could be squeezed into such a small classroom until I did the math silently in my head. Some would have classroom time while the others played outside.

When Lenjoh introduced the teacher to me, I immediately could tell that she was shy and full of shame. I extended my hand to let her know she didn't have worry, that I had come not to make fun, but to

see the good being done by volunteers from other parts of world. I ask myself, *What can I do as a Christian to help the people not only of Kenya, but Africa as a whole?* It was time for the world to set aside greed and start sending more aid to help the people of Africa. This country shouldn't have to rely on tourism as the backbone for survival, and so I prayed and asked the Lord to allow my family, friends, and church family, along with others, to reach out and help the young as well as the old people of Africa. After seeing the conditions of the school and the children, I said to myself, *I'm just as guilty for not sending aid. God has blessed me in so many ways, and now it's time for me to share my blessings and help them.*

As we started to leave the school grounds, I noticed the teacher's office. I walked up and stood in the doorway to look at the contents of the small room. The opening of the doorway provided light for the small office, because there was no electricity. There, in plain view, was only a small desk and a few school supplies. The books seem to be very old, with torn pages and no outer covers. I turned and walked toward Lenjoh and the teacher, camera in hand, hoping that I would be able to take a few photographs. I asked if it was okay for me to take a few pictures.

He looked at me and said it wouldn't be a good idea. Lenjoh made it known that sometimes it's not a good idea to take pictures, which I completely understood. The two of us turned to walk back to our vehicle. Looking back, I waved to the teacher and her students, and they waved good-bye to me, smiling. I said to myself that upon arriving back in the States, the first thing I was going to do, with the help of Lord, was to organize a group of dedicated people who were willing to work hard to see that these children got better school supplies. They needed so much that I didn't know where to start.

We continued our journey, and my very first encounter with the tribal culture of an African village was about to begin. I didn't know what to expect, and I was a little curious to know how they would accept me. Lenjoh told me not to worry, because he had already made

arrangements with the leader of the village for me to come and visit. The first cultural safari visit would be with the Laikipia Masai tribe. Lenjoh said that during the cultural safaris, I would experience some similarity between villages, but the traditions of the people were a little different.

I could tell that we were getting closer to the village, because the number of people standing and talking to one another grew larger and larger. Lenjoh tried to build my confidence by telling me, "Take as many pictures as you like here. Everything is okay, Thompson." His voice made me feel comfortable, even though I was the only American. I was among many interesting faces I had never seen before.

We came to a stop almost immediately, and his friends ran over to say hello to us. Lenjoh kindly introduced me to his friends, and then we got out of the cruiser. He continued to shake hands while I looked around in disbelief. I couldn't believe what I was seeing for the first time in my life. All eyes were on me, and my eyes were fixed on them. It was like a standoff between two warriors sizing up each other.

Lenjoh and I began to walk toward the village, shaking more hands as we zeroed in on the entrance to the village. My eyes still wouldn't admit to what they were focusing on. The entire village, called a Manyatta, was surrounded with cut thorny branches for protection against predators. I was trying to figure how we were going to enter the village's grounds, because the branches were stacked so high that I could barely see the small mud homes that the Masai people lived in. I did notice thick mounds of mud placed at certain locations inside the village for some reason or another, which created a question for Lenjoh, but it had to wait until later. Trying to take a photo of the inside from the outside was going to be a little difficult because of all the surrounding brush. I didn't have time to ask Lenjoh the reason for all the cut branches; besides, I figured I already knew the answer, and my concern was within the village, where I saw several bodies moving as if they were trying to hide from me.

People behind brush

I had my camera in hand, as I had learned to be ready at all times. I didn't want to miss anything that was going to make history for me while here in Africa. As we moved toward the entrance of the village, suddenly a man clothed in a beautiful red wraparound appeared in front of us. He caught me off guard, as I was getting ready to take pictures of the beautiful tribal women who had started to sing and dance as they came toward me. I was excited by what was about to happen—a lifetime dream for me. He extended his hand as Lenjoh introduced the two of us. I could hardly keep my eyes on him because of the ceremony that was starting among the women. It was amazing how beautiful the scene was. I had to force myself to give him my undivided attention, but I thanked him for allowing me to come and visit his village. Lenjoh told me that he would be my guide through the village, and within seconds, I had already forgotten his name because of all the excitement that was flowing through my body.

We entered the small, narrow doorway that led into the village. I asked my guide my first question: why all the cut brush surrounding the village? He told me that it was for the protection of their goats and cattle against predators that prey upon their animals at nighttime. I noticed that the men, as leaders, always walked with a very shiny staff in one hand, while clutching a wraparound on their shoulders and waists with the other, which created one of the many questions that I needed to ask my friend Lenjoh. The brightness of the sun brought out the beautiful red colors that radiated against the dark color of the village men face and hands. As we cleared the doorway to the village, I noticed the women start to sing louder and louder. They quickly gathered themselves in a small group and began to sing a different song than the first. I asked the guide what was happening. He replied, "It is a welcome song for you."

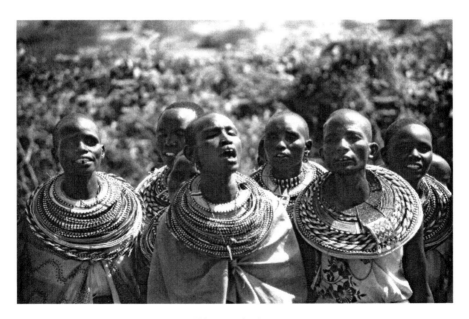

Women singing

My face broke into a smile, producing smiles from the women. Their dancing consisted of many unusual moves along with jumping up and down quickly, and their feet stirred up dust from the ground. A woman stepped out from the group to perform a dance on her own, to her delight. Another woman followed her, and so on, until each woman had danced her own special dance.

The smiles on the faces of the women let me know that it was okay for me to take some photographs. I set my camera from manual mode to automatic. I zoomed in on their faces, where I saw the roughness of their skin. Details showed how the hard work had taken its toll on their skinny-framed bodies over the years. From the young to the old, they celebrated and welcomed my presence in their village with no questions asked. Their faces told a life story of how they had worked to survive the conditions of the bush that surrounded their mud homes for hundreds of miles in each direction.

While the women danced, the men huddled under a tree, playing a game that wasn't familiar to me. One of the men was standing there watching, and I asked him the name of the game being played. He immediately spoke in his native tongue, which of course I didn't understand. The village guide came over to explain that the game being played was similar to chess. He gave me the name of the game, but I could barely hear him, because the singing from the women seemed to get louder and louder, trying to distract my attention away from the men. I quickly took a few steps backwards and knelt close to the ground to take a picture of the game players. Some smiled and posed for a few pictures, but the other, more serious players didn't even pay me any attention.

I had an opportunity to take some beautiful pictures of the members of this village. I was pushing my camera full throttle, moving from one area of the village to another, until a darling little girl just surfaced out of nowhere. She seemed to be three to four years old and unafraid of me as I pointed my camera at her. Her little body was covered with a

long prom dress that exposed her dirty little feet, and she seemed to be waiting for her date to arrive.

Little girl

I stood up and looked for Lenjoh and Happy, but the two of them were nowhere to be found. Then the women dancers formed an outer circle around several women, who danced for a few minutes, then returned to the circle; another group replaced them almost instantly. They had their routine down pat; their stepping together and singing tribal songs magnetically drew a crowd of people from outside the bushy walls into the village. What caught my eye about these dancers was the beautiful handmade jewelry they wore around their necks. The different colors of jewelry, along with their painted faces, made me feel as if I were at a Broadway show. Their pretty, dark, painted skin and the colors of the clothing they wore made it a colorful event as they continued to dance. Each piece of jewelry, some fitting loosely and some tightly, seemed to have a specific place and purpose on their bod-

ies to produce a special effect of movement while doing their dances. It amazed me how they moved their necks and arms at the same time when jumping high up and down, repeatedly.

Women dancing

The older women had control of the performances, and the young women stood back at times to look and learn. As they went on, some of them began to get tired, which was understandable, but others continued to stir up dust from the ground, producing a cloud of joy. I was very well pleased to receive a handshake and personal thanks from each of the women. Each woman had her own distinctive smile along with her short haircut. I also noticed that some had a large hole in each earlobe and two bottom center teeth removed from their mouths, just like the men. This was a tradition of the Laikipia Masai tribe, and it was done at a very young age.

I stopped watching and started taking more pictures. All of a sudden, Lenjoh stepped up right next to me.

"This is unbelievable, my friend," I said.

"Are you getting enough pictures?" he asked.

"You better believe it," I said. I then asked if he could take a picture of me with the women dancers.

"Of course," he replied.

As I walked over to the women, I felt a little awkward. I asked them to please pose for a picture with me. They smiled but didn't understand my request, so Lenjoh stepped in and spoke a few words, and they surrounded me quickly. Some probably had never posed for a picture in their lives. After a few shots, they were all smiles, and they quickly went into another dance routine. This time, I took part and danced with them. It was fantastic, and believe me, I felt like a little kid on top of the world. The smiles from these women could take the breath away from anyone with a heart. The innocence of their faces will always be in my heart until the day I die.

As the women moved to take refuge under the trees from the hot sun, I turned to take more pictures of the small village. The small mud huts, some old and some new, made me wonder what these homes looked like inside. I noticed smoke coming from the top of one of the homes, so with the village guide always by my side, I asked if it would be okay for me to go inside to check out things.

Small home

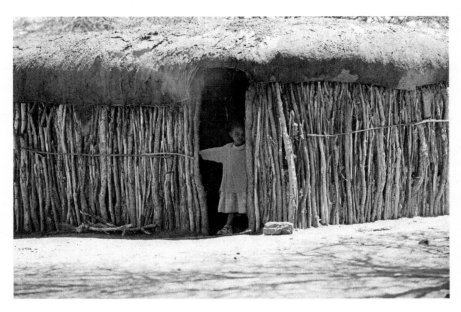

Little boy standing in door way

"Of course," he said, and he chose one that was occupied by a young mother. As we walked over to the small mud home, I looked around, only to notice the crowd of eyes that were always following me, no matter where I went. When the guide reached the doorway, he looked inside and said something to the woman that I couldn't understand. The voice from inside traveled through the darkness of the hut to the doorway, and it sounded as if the reply was something like, "Come on in."

The guide entered first with ease, but for me, it was a little difficult. My tall, skinny frame had to make some adjustments before entering. It required me to bend from my six-foot-one to four feet, two inches in height, just to get in the doorway. Once inside, I had to turn slightly to the left, holding my camera tightly to my side. It was like going through an obstacle course for a first-grader. My eyes slowly adjusted to the darkness, and then I beheld a prehistoric world I'd never seen.

The sight made me think of the days of the caveman. A wood-burning stove would have been a luxury item to the Masai people. In the middle of the dirt floor was a small fire surrounded by three large rocks with wire mesh, similar to a campfire; this was used for cooking. Once I was settled in, I sat down and crossed my legs for comfort. I wanted to start taking pictures instantly without asking permission, but I knew that wasn't polite. Looking around, I tried to figure out some of the arrangements without asking, fearing that the questioning would cause embarrassment to the woman. Never once did she look at me until the village guide introduced the two of us.

After the proper introductions, I felt free to ask questions at will. But before I could get started with my first question, the guide began talking about the layout of the small single-room hut. He pointed out the doorless shelves to my left, which exhibited a few cups and a couple of old pots, all made of tin. You could tell from the soot on the bottom of the pots that some were used for heating food or warming water.

There were also some wooden bottles sitting along the dirt walls of the hut. I asked the guide what the wooden bottles were used for, and

he kindly explained to me that they were used to store milk. It was as if the woman knew what I had asked the guide, because she picked up a wooden bottle and put coals from the fire inside the bottle with a stick, and then she started stirring the coals around inside the bottle. The guide explained that it was a way of cleaning the bottle for future use, to my surprise; this was the first time that I had ever heard of a cleaning method of this kind. He also let me know that milk only lasted in these bottles for a period of two days. Milk was very important to these villagers from day to day. Sometimes the supply was less because the goats might have been far off grazing for days to nourish themselves, and milk, not being plentiful, had to be stored properly to last for a while.

Noticing the fire in the middle of the floor, I asked my guide, "Where are the sleeping quarters?" As far as I could see, there weren't any. But oh, how wrong I was!

He said, "Here."

I said, "Where?"

He stood up quickly and said, "Here, my friend."

The bed was made of wood with four legs, and it had a flat wooden surface that barely could sleep three individuals. Cowhide and goatskins were used to lie on. What he told me next sent shockwaves through my body. "Up to ten people can sleep in a small hut of this size."

It was hard for me to believe, because I could lie on the floor, stretch out my arms, and almost touch the opposite walls of the hut. It was just a few feet longer than it was wide. The guide sat back down to explain to me that a hut was made out of cow manure and mud. Without the manure, their homes couldn't stand the test of rain. He continued to talk to me, but I tuned him out temporarily to ask myself, *Why do I complain when I know God has truly blessed me? I have a wonderful home, car, clothes, and good health and strength.* It made me think of where I came from, compared to where I am today, as we continued to sit and talk.

It was noticeable to me, and maybe only me, that the heat from the fire was causing the temperature to rise quickly. I began to sweat, and as I was bald, my head felt the heat the most. As the smoke from the fire began to thicken, its only escape route was when the woman pulled out a piece of plastic-like material from a small hole in the ceiling. The rays from the sun then passed through the hole, hitting the floor and producing a ray of smoke that was beautiful to the eye.

Just as I was about to end our conversation, another tribesman entered the hut and seated himself. He extended his hand for a shake, and I kindly did the same. He was introduced to me as the tribe's leader. The guide had to do some translation between the two of us, because he could only speak a little English.

As our conversation went on longer, the inside of the hut began to get hotter and hotter. He wanted to know what country I was born in and where I lived. I kindly let it be known that I was from America and that my home was in Texas. His eyes lit up, and a smile ran across his face. I noticed that whenever I said "Texas" in Africa, almost everyone wanted to know about cowboys. They apparently know more about the life of a cowboy than anything else, because Lenjoh asked me on several occasions about the Texas cowboys and movies that he had watched on television.

I changed the subject, because I wanted to know more about their culture rather than talk about mine. I mentioned to him that I was told that the drinking of blood was a tradition of the Masai people. He said it was very important, because it strengthened and nourished the body. The blood came from the animals that they raised, such as goats and cattle. It was only good to take blood from the animal once every three to four weeks. The purpose of that was to allow the animal to graze and build up its blood supply.

I also wanted to know more about the children. At what age did they start herding the animals? He said that a young boy or girl could start as early as six years old. That was truly amazing to me, because they were so young to be working so hard. But I had to understand

that this was the way of life in Africa. I just wished some of the kids back home could see this and realize how blessed they were to be able to get jobs and be paid. It was not about pay here; it was survival. Herding cattle or goats here was no easy job. There was little vegetation, so that meant walking miles upon miles to find food for the animals. This could start as early in the morning and continue to the late evening, walking up and down on rocky ground that is never smooth in any one place, climbing up dusty hills and darting between thorny trees in the hot sun all day long, with little water to drink. Thinking about this should make anyone realize how blessed they are.

I noticed that the leader wasn't a man of questions or answers, because the guide was doing all the talking. Maybe it was because there was a language barrier between the two of us, but the guide did seem to have some education, judging from his fluent English, which I thought was excellent for the village.

I felt like it was time to go now, because my body had been in an uncomfortable position for a period of time. Needless to say, the heat was beginning to get to me. The guide asked if there were any more questions, and of course I said yes. I wanted to know if it was okay to go back outside so that I could take more incredible photographs.

As the leader made the first move toward the doorway, followed by the guide and myself, I could hear more singing coming from outside. These singers had deep voices and sounded very good, like the male chorus of the St. Luke Missionary Baptist Church of Houston, Texas. The voices seemed to be coming from the back of the hut as I quickly tried to exit. First, I had to go back to my four foot, two inch stand and position myself, along with my camera in both hands, to maneuver through the small doorway. Once out, I noticed that crawling would have been a better way. As I stood up, my back cried out for help. My eyes started to weep, because they had to adjust to the brightness of the sun after being in darkness for quite a while.

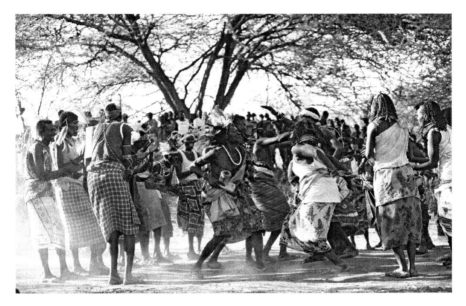

Men dancing and singing

Once my eyes came back to life, I saw that a group of tribal men was face to face with me. I raised my camera, just like a cowboy drawing a gun from his holster. I started shooting photos like I'd never done before. It truly was a sight to see. Never had I seen such an event, nor would I see one again. The Masai warriors sang loudly, as if they wanted everybody's undivided attention. Their ability to jump high made their dancing even more powerful looking, and my camera captured all of it. The precision of their feet along with their hand movements was just amazing for me to see. There were times when I had to put my camera aside for a moment to get the full effect of their dances. I was told that every dance that the Masai people performed told a story. It seemed like they enjoyed dancing even if I wasn't here.

Thank you, God, for giving me the chance to meet and witness other people and experience their culture. It helps me to respect others' ways of life and allows me to pass on to my friends and acquaintances that it is disrespectful to make fun of anyone's culture or traditions.

The men continued to dance with high emotions as the hot sun warmed things up for them. I didn't care about the heat outside as I had inside the hut, because this might be the only time I got to see these amazing people. After each dance, they immediately came together, speaking in their native tongue and wiping sweat from their faces as they agreed on the next dance without hesitation. I witnessed their inclusiveness when the women joined in some of their dance routines. What mostly caught my attention was that they included the elderly in the dances too. The beauty of it all was not the jewelry worn by them or the colorful clothing against their deep, dark skin, but the love that they showed for one another. And yet as I stood there as a photographer, I saw sadness, hunger, and poverty in all their faces. I knew that God could use me in a special way to help these people some way, to deliver them from some of their hardships someday, and this brought relief to me.

Lenjoh approached me from the back, asking, "How is it going?"

I told him, "These are some of the best photographs that I have ever taken."

As the warriors continued to dance, I knew that it was probably time to wrap it up. So I asked, "Lenjoh, what is next on the schedule?"

He said kindly, "Let's start heading back to camp, and we can look for wildlife on the way back."

I put aside my camera to thank everyone for their kindness and hospitality. As I turned to head back to the cruiser, I noticed that some of the men and women had placed several blankets on the ground with many pieces of African jewelry on each one to be displayed and sold. I kindly walked over to peek at each individual blanket with jewelry. I knew that I was going to buy souvenirs before leaving Africa, so why not purchase from the villagers? There were so many beautiful pieces of handmade jewelry, and I just knew that when got back home, I was going to be asked the question, "What did you bring me back?" This was the best time to prepare for that occasion. In any case, whether I

brought anything or not for my friends back home, I just wanted to help the villagers.

I walked up and down, looking at each blanket full of jewelry, I wanted to select from each one, because I knew a blanket represented a household. I called Lenjoh over to get some advice, because some of the jewelry was for women and some was for men. I also told him that I had a little problem: I hadn't brought any currency with me. Lenjoh told me not to worry, and so as he pointed, I selected slowly and carefully from the blankets of jewelry. I noticed that some of the jewelry was similar to the jewelry that was worn by the warriors of the village.

After collecting all the pieces of jewelry, I told Lenjoh that I was ready to purchase my gifts. The village guide and Lenjoh went into African-speaking mode, and I was sure that the two were discussing prices. When smiles covered their faces and Lenjoh reached for his back pocket, I knew that a deal had been struck. After the payment was made, we turned to walk off, and I said my last good-byes. I received many good-byes in return, and I noticed a few villagers get up and go over to the village guide to collect payment for the items that I had selected from their blankets.

As we exited the bushy entrance to the village, a group of Lenjoh's friends was standing next to the cruiser, waiting to say good-bye. I kindly joined in and shook a few hands myself. As we drove off, I thought to myself how good it was to be welcomed by the caring people I had met in Africa. After today's events, I was beginning to wonder what the future held for me over the next few days. I thought to myself, *Only God knows.*

Suddenly Lenjoh asked, "How was it, Thompson?"

I only could say to him, "Thank you. It was fantastic."

He then said, "It is only going to get better." We continued heading back to the campsite on the old, dusty, red road. Lenjoh kept his eyes peeled for anything moving in the bush while driving. I couldn't believe how excellent his eyesight was as he spotted game in the far distance.

To my surprise, the first wildlife I spotted was a Von Decken's hornbill. It was a beautiful black and white bird that looked similar to a large parrot. I wanted to take a photo, but the shot wasn't a good one, because bushy limbs from a tree obstructed my view.

We moved right along for a while before viewing many more different types of birds. The paradise flycatcher, sparrow-weaver, superb starling, drongo, white-crowned shrike, Gillett's lark, and the African hoopoe were just a few of the many beautiful birds we saw on the second day of safari. I could tell that we were getting closer to camp because of the large mountain that we had stopped by earlier to climb just before today's safari.

As we neared the campsite, the turns in the road began to get tighter and rougher, leading us right through what I called the "area of devastation" that had been caused by elephants feeding upon small trees. Passing by this area meant that the camp was only a few yards away. Lenjoh instructed me to get a little rest once we returned to camp, because the staff was about to prepare dinner. I was ready for a short nap and to relax for a while in the luxury accommodations of my tent. Just thinking about it made me feel a little sleepy, and I could see the camp approaching just ahead. One last big bounce from the rough road, and Lenjoh turned off to enter the camp area.

Waiting for us were two staff members, anxious and ready to help me with my camera equipment. They asked me how my first day on safari was. "Great," I replied tiredly.

Heading straight for my tent without any delay, I quickly dropped everything to lie down for a few minutes. It felt so good not to move my old body for a while, because the heat from the sun and the swatting of flies all day had taken their toll on me. Voices from the outdoor kitchen began to fade slowly as I lay motionless on my bed.

"Hello." It sounded like Happy was calling for me in a dream.

I could hardly turn over to answer him, so I said, "Yes, Happy?"

He quickly announced, "Dinner is ready."

It seemed like I had been cheated of my sleeping time, because before I knew it, a couple of hours had passed just like that. I said to him, "Thank you," and his welcome came instantly.

Moving slowly, I exited my tent and noticed that darkness had surrounded the campsite. Beautiful stars that weren't present the night before stood guard over our camp. As a little boy years ago, my friends and I had always tried to see who would be the first one to find the Big Dipper and Little Dipper at night when the sky was clear and full of stars. As I walked toward the bright campfire, I looked up to one of the most beautiful night skies I had seen in a long time.

Looking down again only to notice that Lenjoh was waiting for me, I quickly sped up. He asked me if I was hungry, and I quickly said yes. In an instant, Happy set my African dish before me. I looked at it and said to myself, *Get used to it, American food is far from this menu.*

Lenjoh dug in with me while giving me the agenda for the next day. I ate slowly to let my taste buds adjust to the new taste of food, but in the meantime, Lenjoh was raking it in. I could hear the staff in the background, talking in their native tongue. I was hoping that I wasn't the topic of discussion since I had consumed such a small portion of food.

After dinner, we continued to sit around the camp, listening to many sounds from far away. Lenjoh recognized some of the sounds coming from various animals. I mentioned to him that the river had gone down quickly and the rushing water had slowed down tremendously from the day before. Tonight it had a calm and relaxing sound.

All of a sudden, there were large splashes, one after another, as if a large animal was crossing from one side to the other. Lenjoh jumped up quickly, asking for the floodlight. I wondered to myself, *What could it be?*

Lenjoh seemed to have everything under control. All of a sudden, he said, "Thompson, let's go!" Lenjoh and I, along with one of the staff, jumped in the cruiser and headed into the darkness of the bush. He drove along the side of the river, as close as he could, but trees were in

the way and wouldn't allow him to get any closer. The warrior standing in the back directed the spotlight into the areas Lenjoh ordered.

I asked him what he thought it could be. "Elephants," he said.

I didn't know if I should be scared or excited, but having the chance to see elephants in the wild for the first time would truly be amazing. I was looking forward to seeing the destroyer of all these trees and the creatures that satisfied the flies every day by leaving large mounds of droppings for their dinner. I was a little worried about getting too close, because he had mentioned to me earlier that there had been several killings of people from elephant attacks.

As we followed the twisting roads through the bush, suddenly there appeared two large elephants, crossing our pathway. They ran as if there were no tomorrow. I noticed that even though these animals were very large, they were quick on their feet as they disappeared into the darkness of the night. Lenjoh made a valiant effort to follow, but it was useless, because it was so difficult to maneuver at night through the bush. He then turned the vehicle around and headed back to camp, which was all right with me, because I definitely was looking forward to a good night's sleep. Even though the excitement of seeing elephants was for only a few minutes, it will always be a photographer's memory for me.

I knew it was bedtime, but I had to do one more thing before turning off the light. Quickly, I picked up a pad and pencil to note all the events of the day—yes, my personal diary. I thanked God for what he had blessed me with witnessing in this beautiful country of Kenya.

Third Day of Camp

It was four o'clock in the morning, and nature's alarm was sounding off. Yes, the beautiful singing of the birds awakened me from a deep, hard sleep. My mind told me to get up, but my body said, *No way.* I noticed that I had left my pad and pencil in the bed with me, indicating that I had fallen asleep while making notes about the previous day's events. So I started entering a little more information into my diary about the second day in camp while there was a little more time before the staff summoned me for my shower and breakfast. I can honestly say that that day's activities were a blessing from the Good Lord.

It was about 5:30 AM, and I had started to get myself together when all of sudden, I could hear someone walking toward my tent. Of course, it was Happy singing in a soft, smooth voice as he approached the tent. He said, "Good morning." I told him that I was up and thanked him; his reply, almost immediately, was "You're welcome." The guys in this camp really had treated me very well; sometimes I felt so guilty. I really don't think that James and Kerry Christian could have chosen better employees for their safari company.

I then made my way to the shower tent, where the warm bag of water, secured on its second tree limb of the trip, hung patiently waiting for my arrival. The warm water from the river felt good in the cool of the morning. As I dried off, my ears absorbed all the beautiful sounds that surrounded me. My shower ended with music coming from birds that I'd never heard before. It wasn't like in the States; the African birds started earlier in the morning, testing their voices on anyone or anything wanting to listen to their beautiful singing.

After I made it back to my tent and got dressed, it was time for breakfast, and Happy had it ready for me. As I selected what I wanted

to eat from the breakfast table, I noticed Lenjoh and his staff were having a discussion in the kitchen. There were also camels sitting on the ground, waiting for their participation in today's long haul. I went over and sat down at my special table in front of last night's campfire, which still had smoke coming from it.

I began to eat, and I noticed Lenjoh walking my way. "Good morning," he said, and then he began to tell me about the day's plans. It would be very interesting to me, because Lenjoh said we would be moving camp to another location, which was going to require a great deal of walking. Now I could see the reason for the camels, which were going to be used for carrying the camp supplies and the tents.

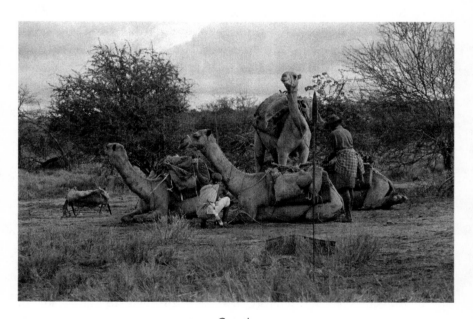

Camels

Later that day, after the move and setup of camp, Lenjoh was going to take me on my second cultural safari, this time to visit the village of the Samburu people. I quickly crammed down what remained of my breakfast so that I could return to my tent to get my camera. I could

tell that today was going to be the highlight and key element of my trip here in Kenya.

The time had come for us to get started on our journey, before the temperature began to peak. I was ready with camera in hand as Happy raised the camels from their resting place, and Lenjoh took the lead. We walked slowly with the camels, and I could tell we would be going at a slow pace today. While we went walking through the bush maze, two of the staff remained behind to finish cleaning up what was left from the old campsite.

In just a short time, we spotted some zebras, which were more plentiful in this area than any other type of wildlife. Lenjoh also told me that the Grevy's is a very rare specimen, whereas the plains zebras are plentiful here in Africa.

As we continued to move on, it became warmer; I noticed that the flies got worse. They were really bothering me, but I knew this was a part of the trip. About an hour into the trip, I noticed that there was a mountain ahead of us, and Lenjoh seemed to be walking right toward it. Out of all the mountains that surrounded us, this one looked very familiar to me. I brought up the rear in the convoy, for the simple reason that it allowed me to hang back and take photographs at will without interrupting the flow of things.

Looking at the landscape of Africa and being able to see for what seemed to be hundreds of miles in all directions made me realize how beautiful Africa really was, and yet it was crippled by the hunger pangs of its people. Only God knows the reason, and I believe he can fix any situation at any given time. He is good and always will be, but he also allows us to help and to show our love for those who are in need. It amazed me how happy the Laikipia Masai and Samburu people were, having little in life. On the other hand, there are those who have plenty and sometimes take things for granted, thinking that they will always have abundance.

As we got closer to the base of the mountain, I noticed that it was the same one that we had climbed earlier. Happy led the camels right

up to its rocky edge to give them some rest. Lenjoh and the other warrior started the climb. This time it was from the opposite side of the mountain, which was a lot easier for me.

As we reached the top to explore the vast, wide area, we looked for wildlife. Lenjoh, with his good eyesight, spotted impalas. I raised my camera to take more photographs, switching from a color roll of film to a roll of black and white to capture Africa in a different way.

After about thirty minutes or so, it was time to descend from the mountain and continue our journey to the new camp location. We walked for another few hours, and then Lenjoh instructed Happy to stop the camels. To my surprise, he called me Carlyle. It was a little funny hearing him calling me by my first name, as his accent got in the way of his trying to pronounce it with clarity on his first attempt. He asked, "Would you like to ride a camel for a while?"

Never in my life had I ever ridden a camel. Happy made one of the camels lower itself to the ground, allowing me to get on the back of the animal. It was the ride of my life. I quickly learned that there was no comfort when riding this animal. I twisted and turned from side to side, searching for the best sitting position, but it was impossible. Once the ride began, it wasn't all that bad. The rocking back and forth got to me a little, but I soon mastered the riding technique. Happy looked back at me and said, "Now you can see like the giraffe," which was great, but not for photography.

We continued for another few hours, and then we made a stop to give the camels and ourselves a break. The sun began to do its thing, and the temperature rose. Happy immediately went to work, bringing Lenjoh and me some snacks to eat and water to drink. Never in my life had I thought I'd be in Africa, photographing wildlife and having a guide of my own introducing me to the culture of the Laikipia Masai and Samburu people.

As we sat, Lenjoh told me that it wasn't much longer to the campsite, and then he asked me if I was okay. We had been traveling for four hours, and not even half a day had gone by completely. It was

amazing how far one could walk and not even realize it. Now it's easy for me to understand how and why the people of Africa can walk so far: they have nothing but time on their side.

Once we were refreshed, it was time to move on to our final destination. I hoped to see more wildlife; we hadn't seen very much movement in the past few hours. As we continued our steady pace, a watering hole seemed to jump out of the middle of nowhere. There were many different types of animal tracks, and I could see this being a stopping point for any animal traveling by night or early morning. Happy led the camels to the hillside next to the pond, and I took the opportunity to go to the lower side of the pond, because I saw a great chance to take a gorgeous picture of the camels' shadows on the water.

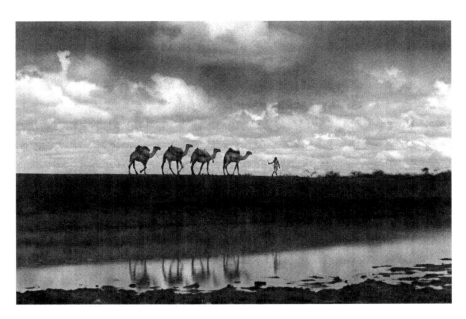

Camels at the pond

After shooting five or six frames of Happy and the camels, I lowered my camera to my side and continued to march forward. I sped up to

catch up with Lenjoh and let him know how pleased I was about my days already spent here.

With a smile on his face, he said, "Camp is just around the corner."

Within the next few minutes of walking and talking, I could hear the voices of the staff and see the camp coming into view. These guys were really good—they had already set up about 80 percent of the campsite. The only things that were left to set up were on the backs of the camels. To my surprise, my tent was already set up, and I was ready for it. Even though we had walked for a long time, it really hadn't been that hard. It was good to be in camp for a short rest, because Lenjoh would be taking me on my second cultural safari later that day.

When I awakened from a short nap that really did me good, I realized that the temperature never had gotten hot enough to make me take off any clothing during the morning's walking safari. It was funny, because at times I felt it getting hot, but there was always coolness in the air. It was like a giant air conditioner was cooling and regulating temperature throughout the day.

Before I got started for the second half of the day's activities, I made notes in my diary about this morning's walking safari. Not much had happened, but we had seen a little taste of wildlife when we climbed the mountain. There were more rock hyraxes (a rabbit-like animal), and the agama lizard, with its beautiful reddish orange head and a bluish body. Both species lived among the rocks. To my surprise, the unstriped ground squirrel took center stage during this morning's walking safari, because I noticed how fast the little critters could run and change directions in a split second. If I never get to see another animal, it will be okay, because I have seen more than I deserve. My main concern was to meet the people and learn what I could about their culture in a short period of time. I wanted to capture, through photography, their way of life, witness their living conditions, and observe firsthand the different ceremonial dances performed from village to village. I wanted to let them know that I was not there to be critical of them, but to show my concern for their well-being.

Once again, I could hear Happy marching toward my tent to let me know it was time for the journey to the Samburu Manyatta village. "Hello," he said to me in his usual tone of voice.

I gathered my camera equipment and exited my tent. Lenjoh was waiting for me. Happy jumped aboard to make the trip with us. From the look of Lenjoh, he seemed to be more excited about the visit to the Samburu village than I was. He probably had made this trip many times before on other safaris, but I guess this one was a little special to him.

Once on the red-carpet road that filtered through the bush, the riding time allowed me time to think once again about my family back home. Even though I'd been so excited about the trip, there were questions on my mind as to whether I should have taken the trip, because I felt that the timing was always wrong, for some reason. I thought about my two kids, both in college; they could have used the money I had saved for this trip. Being semiretired had a little do with it too, plus I knew the money also could have been used at a later date for an emergency situation. But I continued to pray to God, saying, *If it's your will, let this trip be possible.* And on October 24, 2006, the Lord did exactly that.

We'd been driving for a while when I noticed the road we were traveling had washed out very badly. Lenjoh, being an expert, made it look easy. There were times when he had to stop and get out to flip the switch on the front tires of the cruiser for four-wheel action. That's just how badly the earlier rains had been, causing some of the sandy roads to disappear.

After having driven for almost two hours, Lenjoh decided to pull over and have a short lunch. Happy had brought all the fixings for our lunch. Lenjoh and Happy had a few words to say in their native tongue, which meant I was left out of the conversation. But that was okay with me, because sometimes I loved hearing them speak. Then, out of nowhere, we heard several voices, which seemed to be coming from up the road. I tried to see who the voices belonged to, but the

trees blocked my view. It sounded like two women were talking to one another. Suddenly, the women appeared. When they got closer to us, Lenjoh spoke to the women, which slowed them down to a stop. Happy and I continued to eat while Lenjoh got up and walked over to talk to them. After a few minutes, the women moved on, and Lenjoh was ready to go.

Happy quickly gathered everything, and before I knew it, we were on our way. As I looked out the passenger window, I saw a beautiful view of Africa. It was so amazing how a little incline in the road could produce scenery that one could never forget. As we were about to top a hill, Lenjoh pulled to the side of the road to let me take a few pictures of the miles and miles of breathtaking views that surrounded us. I thanked Lenjoh, and he said there was more to come. I tried not to stop him in the middle of his driving, because I knew we were on a schedule, but I had to get a picture of this unbelievable site.

As we approached the top of the hill, I could see in the distance ahead a small town sitting all alone in the middle of nowhere, as if all contact with the outside world had been lost. Lenjoh asked if we could stop there for a few minutes, "Fine with me," I replied.

We slowly made our way down the long hillside until we approached the outskirts of town. I instantly noticed the old buildings on each side of the road and how they looked as if they were trying to tell me something silently. Driving slowly and looking from side to side, Lenjoh finally pulled over in front of a building that appeared to have no front door. I wanted badly to take some pictures, but Lenjoh, once again, didn't think it was a good idea. I had to remind myself of the planning stage of this trip, where I had read in several articles that photography wouldn't be allowed at certain times.

When Lenjoh got out of our cruiser, a couple of guys walked up to him and smiled as they shook hands with him. Unbelievably, this was the first time I felt a little afraid. But when I saw the smile on the men's faces, I relaxed a little and shook their hands while sitting in the cruiser. I wasn't going to move until Lenjoh gave me the word. I didn't

want him to feel like I was uncomfortable around his friends, so I kept a Texas smile on my face at all times. He continued to talk, and I continued looking around, especially at the guys that were sitting off to the side of the doorless building, because there were no smiles on their faces. All the old buildings in this town were leaning on one another, making it look like they were connected together, like an outdoor shopping mall.

Lenjoh said, "Get out, and let's drink a soda."

I removed my camera strap from around my neck and placed the camera on the seat. We simultaneously whisked up the land cruiser's windows and locked the doors. As we entered the doorway of the small building, there were more men sitting and socializing. I noticed that there were more patrons than tables to sit at. Lenjoh and I seated ourselves on two available barstools, and our sodas were brought to us, except for Happy; he didn't want one. Then the African accents began to explode from all directions, and all eyes were on me. Everybody was talking except for Happy and me; Happy stood next to a wall, waiting patiently for our next move. To my surprise, a few of the men could speak English very well, and that was when the questioning began about Texas and how I liked living there. I glanced over at Lenjoh and saw him finishing his soda, which made me hurry up with mine. Once I finished, Lenjoh stood up, and that was the signal that it was time to go.

Saying good-bye didn't take long, and before I knew it, we were on our way, going across a large riverbed and up a hill, where I began to see more people. This told me that we must be closer to our destination. We topped another hill, and then Lenjoh turned off the road and drove though the bush to an open area flooded with villagers. We stopped on a small hill to look down onto a large area that had been cleared and was as smooth as a basketball court. It resembled a small arena used for performing. I assumed this was the place where all the ceremonial dancing took place. Farther down the hill, I could see another part of the riverbed that we had crossed earlier, where there

were children playing. Up on the other side of the riverbed, I could see the homes of the Samburu people. The homes looked like they had been placed by hand in their specific locations to resemble a little subdivision. It was so beautiful to see their homes sitting in the midst of the small, green trees, highlighted by the red color of the ground. It was a sight to see and would be a dream picture on canvas to an artist's eyes.

Lenjoh started walking down to the area where everybody was standing, and I waited. In the meantime, I gathered all the film for my camera. A group of kids walked up to me as if they had never seen a camera before. Some were dirty, with torn clothing on their innocent little bodies, while others didn't have any shoes on their feet. I felt bad because I didn't have anything to give them, so I shook their rough, scarred little hands to let them know I could be as friendly as they were. One of the young kids extended his hand as if he was asking for something from me. I couldn't figure out what he wanted. I looked all around until I concluded that the child wanted the plastic containers that my film came in.

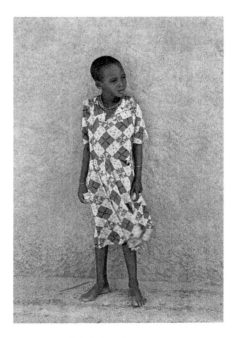

Child standing alone

How stupid could I have been? The answer was in my hand. I quickly removed all the film from the containers. As I handed each child a film container, it created a big smile on his or her face. It looked and felt like Christmas time as they charged toward me to get their hands on a container. After passing out all the empties, I was disappointed, because I didn't have enough to give one to each kid. In the back of my mind, I wondered what it would be like if these children could receive toys like other kids, knowing that it would truly be a blessing to them. Sometimes I couldn't tell whether a young child was a boy or a girl, because they all had short haircuts. Looking at the unwashed clothes that they wore gave me a clue about whether they were young girls or boys.

Looking up, I noticed that Lenjoh was walking back to the vehicle, where I stood waiting for him. He had with him a young man dressed in red tribal attire with a staff in his hand.

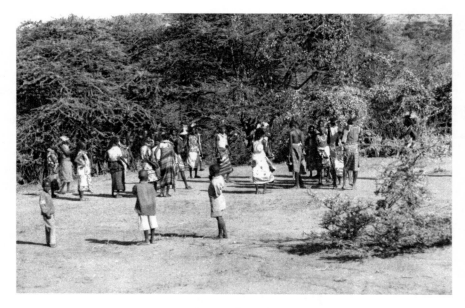

Group of people

Before they reached me, I noticed a large group of dancers in the background; men and women were about to perform in the cleared-out area. They started to chant and sing their native songs as people began to gather from all directions. As far as I could tell, the women started first, with the men looking on, waiting excitedly for their turn. I finally had a chance to put a roll of film in my camera, after passing out the film containers to the children. I began walking quickly toward Lenjoh and the smiling man, to speed up the introduction, because I was ready for some camera action. I think Lenjoh knew this from my eagerness to get down the hill to the dancers.

The smiling man and I both extended our hands at the same time with a smile. I could barely hear his name above all the loud singing and chanting that was going on. Paul Nachio was his name, which was somewhat interesting, because he had an American first name. He spoke fairly good English, which indicated that he'd had some education as a young Samburu man. Talking, we made our way down the

hill to the tribal dancing area. He began by telling me about some traditions of the community that really impressed me. The community elected leaders for a certain period of time, just like our leaders back home in the States. Keeping him talking made me pick up on his speech quickly, because even though he had an accent, his English was very good.

We continued to walk, and before I knew it, I was right in the middle of things. The Samburu people were extremely friendly to me at all times. I asked my guide if it was okay for me to take some pictures, and he said, "Yes, of course."

Pulling my camera up from my side, I went to work, furiously shooting film as fast as I could. I didn't realize how quickly I was using so much film. There were times when the flies were all over my hands and face, causing me to lose concentration, but I knew that this chance might never come again, so I had to make the best of the situation and continue shooting.

Dancing is a way of life for the Samburu people, from the young to the old. One beautiful moment that caught my eye was when I looked through the trees and bushy weeds and saw down below, next to the dry riverbed, this very old lady leaning against a large tree with her staff in her hand.

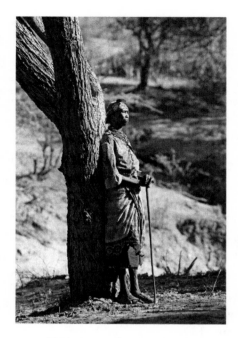

Old lady standing next to tree

There were a few people with her, standing in a semicircle and chanting hymns in their own way. Repeatedly she used the end of her staff, tapping the ground to match the rhythm of the songs. It was as if she was directing a small African choir. I noticed there was another large, cleared-out area nearby for dancing. The old woman smiled, wrinkles covering her face, telling secret stories of her past; she probably once was a dancer.

Thinking there were two different tribes from the same community left me totally confused, and that's when I walked over to the community leader to ask him what was happening. He pointed and told me to watch the large group of dancers, consisting of men and women bunched tightly together with hardly any space between them as they jumped up and down continuously. They all grabbed each other's hands, and in one motion, a warrior broke free from the group, leading all the dancers in the form of a human chain. They circled several

times, creating a curtain of dust as they disappeared through the trees, heading down to the other cleared-out area near the banks of the riverbed. There they joined the others, along with the old lady, who was leaning against a large tree that also overlooked the riverbed. You could tell she wanted to join in with the other dancers, but no invitation was offered.

The human chain continued, and they circled several times. All at once, the men broke the chain to group together. The women then formed a group of their own, facing one another. It was a beautiful picture to see, and it was all being captured by my camera's lens. The show was on, with the men challenging the women with their creative steps and high jumps. But the women answered with their low, twisting moves and dazzling feet, and both groups sang the same song. The community leader knew that I was experiencing something that I'd never seen before, and guess what? He was right. I was missing so much while trying to take photographs, but I had to take these incredible moments back home with me to show rather than just to tell. The dancing went on, and I was looking around for more pictures to take. Squatting on the ground was another old woman, clutching a baby tightly to her chest. The baby seemed to stare at me hungrily with its innocent eyes.

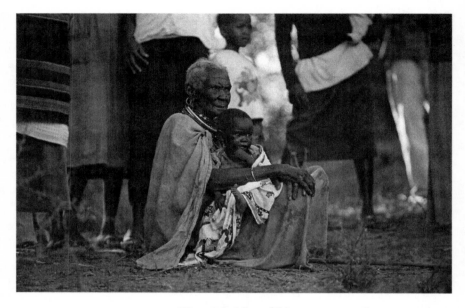

Woman holding child

The moment touched my heart as I zoomed in to take the photo-
graph. This touching photograph will live in my heart forever and ever.
God shows us certain things in life, and after he presents them to us, he
sits back and notices how we will respond. Even though this trip was
during my vacation time, I now conclude that it was really not about a
vacation, but the start of a future mission, helping others through the
eyes of a photographer. These photographs will serve the purpose of
showing the world that we must set aside ourselves sometimes, in order
to show what is called "agape love" for one another and for the less for-
tunate people around the world.

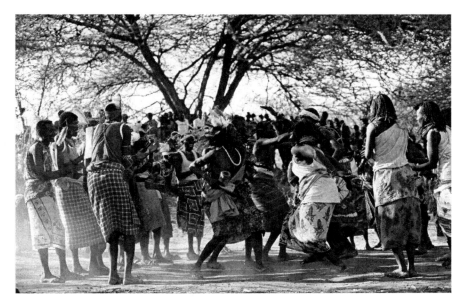

Village dancers

As I continued to take photographs of the tribal dancers, I noticed that the crowd was getting larger by the minute. The sun's rays piercing through the trees highlighted the bodies of the dancers, with their colorful clothing and jewelry adorning their necks and arms. Their bare feet patting and stomping the ground generated huge clouds of dust that began to surround us as if taking us hostage.

I moved to the top of the hill, looking down at the dancers, to get away from the dust. The dancers gathered into one large group, singing old African hymns from the past as they jumped up and down. Yesterday's cultural safari had involved me going into a village that was deep in the bush, where survival was difficult; today's safari introduced me to a community of tribes that consisted of several hundred or so people with better living conditions.

Time passed so quickly that I forgot all about Lenjoh and Happy; being at the top of the hill allowed me to see the two of them next to the cruiser, talking to some friends. As I was talking to Paul, the com-

munity leader, a loud voice from the group of dancers caught my undivided attention. Immediately, they performed their final dance. They formed a large circle, and one by one, each performed his or her dance.

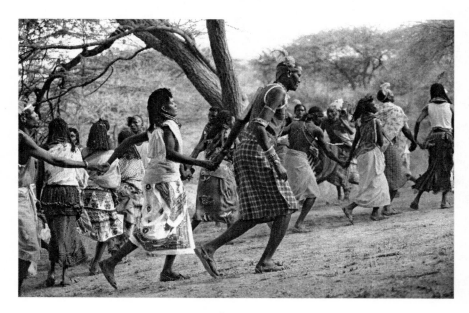

dancers

Then they broke the circle quickly to form a single line, and they snaked their way through the trees and spectators to depart from their ceremonial dancing grounds. As everyone turned to follow the team of dancers back up the hill, I noticed a poor, middle-aged woman that was working on her little home made of mud and sticks of wood. It wasn't totally finished, because I noticed that she was trying to place a large piece of cardboard and tin on top for a temporary roof, and she was barely tall enough to slide her makeshift roof into place. Her home had a slight lean to it, because it was being constructed on the incline of this hill where everybody had been standing, watching the dancers earlier.

I slowly walked over to speak with her, and she looked at me with a big smile on her face, as if she was saying, "You are welcome." You could smell the fresh mud and cow poop from the roof. I looked around to see if there was anyone helping her at the time, but there wasn't, to my disbelief. She was building her own home without the assistance of anyone. I asked Paul, the community leader, how long it took to build a home of this type. "It will take her about two months," he replied. The woman invited us in for a tour of her new home.

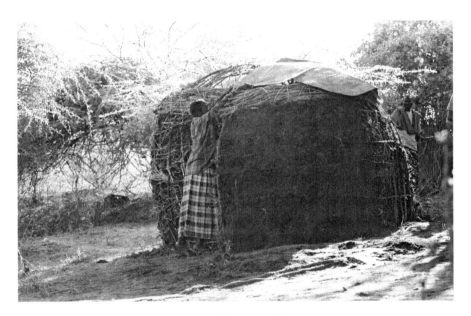

Woman building mud home

Once again, I had to bend down, twist, and turn to get in the small doorway. As I made my way through the doorway, I turned my head upward and noticed that the roof was half completed. The way she had fitted the sticks together tightly for the siding of her home was like a work of art, and the roof was the only thing left for her to complete. But she had to wait, because without mud and cow manure mixed together, the roof couldn't be finished. Combined together, these two

ingredients create a very hard surface to withstand the rain. There wasn't enough cow manure to mix with the mud, because the cows were miles off, grazing. There was little or no food for the cattle because of the summer drought; this meant that she might have to wait days in order to complete the roof of her home.

I continued looking around, and I saw how the woman had carefully placed all of her items in their rightful places, taking advantage of the small space that was available to her. I said to myself, *What if my new home were only a one-room walkup?* It didn't take me long to realize how God had truly been good to my family and me back home.

I noticed that she had a small bag of beans on the floor, and a pot of water, as if she was getting to ready cook today's meal. I didn't want to stop her from cooking and working on her home, so I told Paul to thank her for letting me visit her home. While he was interpreting the message for her, I pulled some African currency from my pocket to give to her and the guide. I didn't have enough money to give to everyone, so jokingly I asked her not to tell anyone where she had gotten the money from, and with a big smile, she nodded her head.

As we exited the lady's home, I realized that today was truly a blessed day for me. If I got to do nothing or saw nothing else, my trip to Africa had been a success. It opened my eyes to see their way of living, their traditions, the clothing worn by them, the different types of food eaten, and what it was like living in a village where a one-room home could be made of mud and cow manure. The trip so far had been more of an educational experience than a photography mission. It helped me to understand life and the importance of time, which can get your attention quickly with a swift slap, letting you know that it is not always going to be easy in this lifetime.

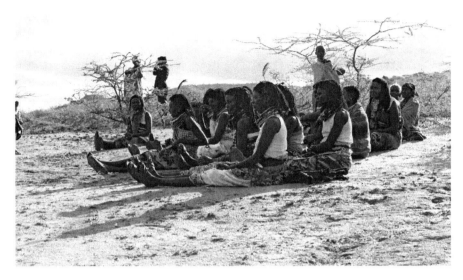

Women sitting

The crowd had shifted a little further up the hill, where I noticed Lenjoh standing and talking to some of the tribal dancers. Paul and I quickly joined them, because I wanted to take more pictures. It was a little funny for me to see the men sitting as a group on the ground in one area and women sitting in another.

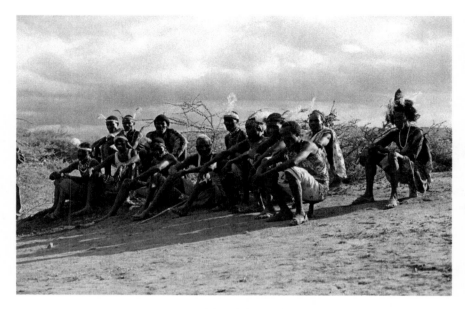

Men sitting

Just a few minutes ago, they were challenging one another during their tribal dancing, so I figured this was the right time to ask Lenjoh if he could take a few photographs of me sitting with both groups. I quickly got in the front row with the men, and before I knew it, the camera was firing off frames. As I repositioned myself for another picture, I felt something being placed on my head by one of the dancers. It was a beautiful headpiece that was made out of black and white ostrich feathers.

After my photography session with the men, it was now time to join the women. Quickly I got up and walked over to the group of women, who were anxiously waiting. They were laughing and giggling as I sat on the ground between them. Then Lenjoh began taking photographs as if he was an experienced photographer. A large crowd of kids were standing and watching, as if their turn was next. There was no way that I would have left without taking some pictures with the little sweethearts of the land. Lenjoh, being the person that he was, didn't mind

snapping a few more pictures as all the kids joined around me, laughing and reaching out to grab my hand. They were so excited about being photographed; probably many of them had never stood in front of a camera.

I thanked Paul, a great community leader, once again for his help in educating me on the traditions of the Samburu people. I told him that I would love to keep the line of communication open between the two of us, to which he agreed wholeheartedly, and we then exchanged mailing addresses. It was hard for me to leave without asking him some of the most important needs among the people. He let me know that school supplies for the children were very important, so that they could keep up with the changing times. Next, to my surprise, were cattle, which were very important to every man, woman, and child. You would think that clothing would be first on the list, from looking at how so many of the children's clothes were torn and dirty, with hardly any buttons to keep them from falling off.

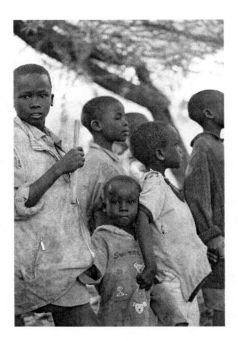

Group of boys

I let him know that when I got back to the States, the pastor of my church and I would get together and propose a plan to meet some of the needs of his people. "Poor" is only a word, but when one can see how the Samburu and Laikipia Masai people live in the adverse conditions of Africa, it should make any person say, "Thank you, Lord" every day for just meeting their needs.

As Lenjoh and I were getting ready to go, one last handshake was appropriate between two newly made friends. "Good-bye," I said. I waved to everybody, and in return, they all waved back. Lenjoh started the short walk back to the cruiser, and I followed close behind. All of a sudden, the warriors started laughing at me for some unknown reason. I turned to look at the community leader, who also had a huge smile on his face. He said, "They said that your skin is the same color as ours."

I could only grin and say to myself, *Yes, it is.*

It had been a very long and tiring day. A sleepy feeling began over-taking me as the rough ride in the vehicle started to take effect. It was rocking me back and forth, which was the perfect formula for putting anyone to sleep.

Lenjoh asked me, "How was it, Carlyle?"

"It was great," I replied. I was stunned, and I woke up a little, because he called me by my first name, which he'd had trouble pro-nouncing from day one of camp. We continued down the red-carpet road. Lenjoh told me there had been a wedding earlier that day, and he asked if I wanted to go to the reception being held at another village.

I wasn't going to turn him down. I said, "Yes, of course."

The good thing about this visit is that we didn't have to drive far to get there. After driving for about half an hour, Lenjoh veered off the road onto some really rough terrain, and we continued on to the village that was within our sight. I couldn't tell one village from another; they all looked the same to me. But once inside, I could tell the difference, because each had a unique layout.

We finally made it to our destination. Lenjoh told me that he would speak to the parents of the newlyweds to get permission for me to take pictures. In certain areas, photographs are allowed, and in others, they are not. Lenjoh sometimes had to pay to get permission for me to pho-tograph. It didn't dawn on me until now that safaris were a source of income for the villages.

After our brief conversation in the cruiser, I quickly retrieved my backpack to get more film. I was going through film like drinking water with a hole in the glass.

There was something different about this village, and I just couldn't put my finger on it. The father of the bride, whom I assumed to be the village leader, met us at the entrance of the village. Lenjoh introduced me to the father and a few men who walked up to us. As I looked around, I noticed that all eyes were on me. I saw some people walking as if they were trying to get out of my view, while others stood behind a large tree, or disappeared into a small hut.

In the meantime, Lenjoh and the bride's father had disappeared outside, beyond the bushy walls of the village. Yes, I was standing alone with my camera in my hand, frozen like a statue. It seemed like my eyes were the only parts of my body that could move. I had visited several villages before, so I didn't know why it seemed so different now. I continued to look for a while longer, and then it dawned on me. I had forgotten that these were the people from the wedding earlier that day. Everybody had a place of his or her own when it came to sitting, playing, or dancing. The older men sat around a large tree, having a conversation of their own, while the older women in their beautiful attire sat on the ground in another part of the village. Several of the older women in the group were blind, and I could hear one of them talking with a very loud voice. For some reason, she seemed to be upset and restless, and her friends were trying to comfort her. Hearing them speaking in their native tongue made me wish I had the ability to speak their language.

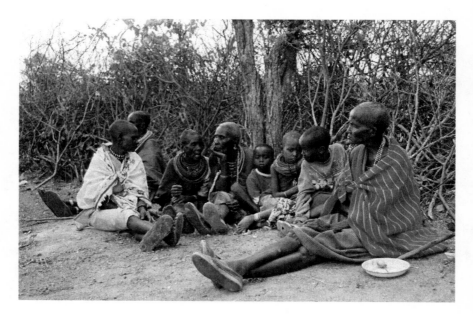

Old women sitting

I saw many opportunities to take some fantastic photographs, but I had to wait for Lenjoh's word. It was time for me to wander around, so that the villagers would recognize me and not be afraid to let me photograph them. I smiled and waved as I walked slowly, which gave me a chance to enter their world, from the smallest child to the oldest adult. I couldn't blame them for feeling uncomfortable with me, because what person would let a total stranger come into their home to take pictures? Even though the opportunity presented itself so many times, I had to be patient. I received some positive and negative responses when I pretended like I was going to take a few pictures. This let me know that I was doing a fairly good job with some, but others sought cover quickly, apparently feeling ashamed. When I had almost completely circled the village grounds, I stopped to watch a certain young woman preparing a meal outside. She was cooking a pot of rice over a hole in the ground filled with hot coals, and there were other women washing the dishes in a large pot with barely enough water to finish the job.

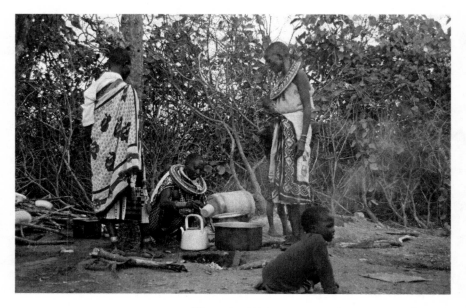

Women cooking

This was the first time I had seen cooking done this way, because most of their food preparation was done inside. The woman didn't seem to mind my watching; she didn't even look at me.

I went back to where I had begun, and I saw Happy standing with a beautifully dressed young woman. Her smooth, dark face seemed to have the skin of a baby. The two seemed to be deep in conversation, and I didn't want to interrupt them, but then Happy call out for me to come. As I walked slowly toward them, Happy's smile got larger. I knew an introduction was coming, so I extended my hand for a handshake. Happy, smiling hugely, introduced her as his wife. She had nothing to say, but a small trickle of a smile graced her face, and without approval from Lenjoh, I asked if it was okay to take a picture. That familiar smile of Happy's was the signal for me to begin firing my camera. After taking a few pictures of the beautiful couple, I informed Happy and his wife that I would mail them a picture. Happy told me

that his mother and sister lived in this village. I asked him if he would please point them out to me while I was out taking pictures.

It had been some time, so I drifted back toward the entryway of the village to look for Lenjoh. There were so many people entering and exiting the village that it looked like ants running for their lives. I decided to stay put and wait for him.

Happy called out my name and pointed to his mother in a group of women that were about to start their tribal dance. They gathered together closely to start their singing and dancing. Once the action began, the crowd grew larger, and I saw Lenjoh walking in my direction. I hoped that he had good news, so that I could begin photographing before everything really got started. Lenjoh announced to me that it was okay to take pictures. Before he could finish saying what he had to tell me, I had already zeroed my camera in on the singing group of Samburu women.

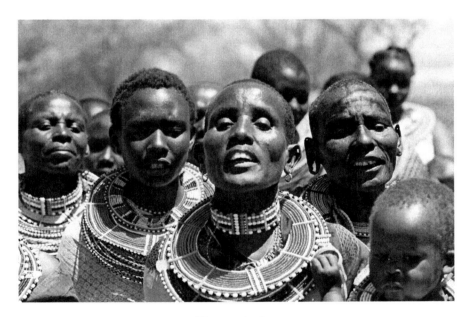

Women singing

They began singing from the heart as they walked around the live-stock holding pen inside the grounds of the Manyatta; the pen was made up of thorny tree branches, built in a circular form that was similar to the outside of the village. A touching moment for me was when I saw a blind woman sitting off to the side on the ground, singing as flies swarmed around her face as if trying to interrupt her beautiful voice. I began turning in all directions, capturing special moments I'd never seen before.

All of a sudden, the grand prize of them all stepped forward out of nowhere. It was the groom and Happy coming my way, and I dropped to my knees quickly to take some photographs. The groom looked very strange to me, because the hair on his head and his neck was a deep reddish-orange color. Once I was back on my feet, Happy introduced the groom to me as I stared at him from head to toe. His head and neck were painted because it was a wedding tradition; the paint must be worn for a certain period of time before being removed. The sun-light highlighted the brightly colored paint, and the many-colored beads around his neck and arms truly made him stand out from the other men in the village.

Happy gave me a rundown of all the different colors of the groom's clothing and explained what each symbolized. There was a long strip of lion skin tied around his waist to indicate strength. The best man was dressed similarly, with the same painted features.

Something about this scene was missing, and it didn't take me long to figure out that the bride wasn't present. "Happy, where is the bride?" I asked.

"In the hut, along with some of her friends," he responded. I was hoping that I would be able to take a few photos of the couple. We walk over to the small hut; the sound of the ladies' voices rang out loudly with happiness from inside. The father of the bride entered the small, one-room hut, and the voices became louder. After a few more minutes passed, the father reappeared and confirmed that the bride would be out shortly. I was trying to decide where to have the couple

stand for pictures, and the best place that came to mind was outside, next to the bushy walls of the village.

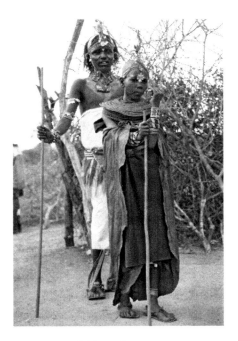

Bride and groom

The bride finally came forth, and the sight of her was amazing to witness. She was one of the most petite brides that I have ever seen, and she was beautiful. Her body and the wedding dress she wore were painted entirely. Since I couldn't speak their language, I had Happy tell them how I would like to photograph them. They cooperated very well, and the short photo session was a success.

As we walked back onto the grounds of the village, there were more photographs to be taken. As we entered through the bushy fence, I saw two little boys, one standing and the other sitting, that captured my heart almost immediately. It looked as if their parents were neglecting them. If children today in the States came even close to looking like what I have witnessed in Africa, their parents would be in serious trou-

ble. It was so hard for me to understand the situation here, as it involved seeing the poor conditions and the environment in which these people lived. How do you explain to the world the reasons why poverty runs wild here in Africa?

What I admire about Samburu culture is that they all work together to care for each other's children. I often saw old women participating in caring for children by carrying babies on their backs as they traveled for miles from village to village, during the day, when temperatures were at their highest. Children played hide and seek in places full of thorny trees and large areas that had been carved out by the heavy rains, deep enough to be used as army bunkers. They had to be careful of the large anthills, which were wide and tall enough to make a small child disappear easily if he or she stood behind them.

As the brightness of day started to dim a little, it was time for me to look for Lenjoh. I knew it wouldn't be hard for me to spot him, because he was the only person wearing a baseball cap and a broad smile. I continued to shoot more pictures, because I knew that time wouldn't allow it in the next few hours. Before I knew it, there was Lenjoh, standing in front of my camera and talking to the bride's father and some other men as I zoomed in on them.

As the evening sun started taking over the afternoon, people began to head to their own homes to beat the darkness. Happy and the groom looked as if they were saying good-bye, when I noticed a strange instrument that the groom was holding. I was ready to go, but my curiosity took over when it seemed like he was about to start playing. He knelt on one knee and began to play the simple instrument made of wood and a few strings of wire, and he produced some of the most beautiful sounds. It was as if he was playing a harp, as a musician would in an orchestra. As he was playing, he continued to smile at me as if he wanted me to take a photograph of him, which is what I kindly did several times. I thanked him and rose to my feet, because it was time to depart and head back to camp.

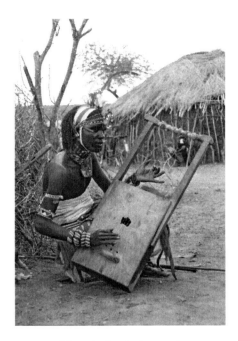

Man playing instrument

I waved good-bye to my new friends as we drove off; it had been an excellent day. This would be one of the most unforgettable trips in my lifetime. Just meeting people who were so kind and willing to share their traditions and go out of their way to make strangers feel at home was something special. I let Lenjoh know that I appreciated his help in making that day's cultural safari a success.

It was almost an hour into the drive back to camp when out of nowhere, a woman appeared, walking with a baby on her back, piggyback style. She looked very tired from carrying not only her baby but also supplies in a bag, along with a large jug, probably containing water to drink. Kindhearted Lenjoh told the woman in his native tongue to climb aboard. As we continued driving, I asked Lenjoh if it was normal for women to walk alone in the middle of nowhere with their babies, especially in the bush without someone to protect them.

He quickly answered, "Yes. It's the women's responsibility to take care of the children, and the men's responsibility is caring for the entire family." It didn't dawn on me until I asked him and he said that, but so far I hadn't seen any men carrying babies on this trip; it always had been the women.

I was beginning to get a little sleepy from the rough riding when I noticed the cruiser slowing down. We came to a complete stop to let off the woman and child. I recognized this as one of our turnoff points from the old, leaning, ragged, rusty street sign. It was also an indication that we were very close to camp. I was ready for a little rest and relaxation, topped off with a hot shower.

Lenjoh must have known that the campsite was just one turn away, because he asked me, "Well, Carlyle, how was today?" I had known that he would ask that question eventually, because it was his end-of-the-day question. I think he already knew what my answer was going to be, because a large smile that appeared on his face when he saw mine.

As we entered the campsite, the waiting staff could be no happier to see us than I was to see them. I jumped out of the cruiser as it came to a stop and rushed to put away my equipment. I sat on my bed and began to review the day's events. I thanked the Lord for another blessed day, for if it wasn't for him, none of it would have been possible. Lying down for a short time gave me time to fight back the tears, and I picked up my diary to write.

It was a sad day for me to write about; I had seen firsthand what it was like to be poor. I realized that poor was poor, but when I looked at the poor people back home and compared it to the situation in Africa, I thought the poor people back home did have a chance to change their lives, with the abundant amount of resources from different organizations; whereas in Africa, the people had a very slim chance of getting help from anyone. The world as a whole must realize and come together to support not only the people of Africa, but all races of people from the four corners of God's creation.

This time I didn't hear the footsteps before the voice that sang out hello at the entrance of my tent. As usual, it was my favorite voice: Mr. Happy's. I knew it was dinnertime, so I let him know that I was on my way. I just wanted to finish sewing up some loose ends in my diary entry about the day's trip. To my surprise, I really wasn't hungry, even though we had been gone just about all day. I had been so excited, but I wasn't going to let that send me to bed without eating something.

Once I was seated at the small dinner table, Happy began to pile it on. It was an all-African dish tonight, and to my surprise, it was a steak. I started to feast, and Lenjoh came over and joined me. The two of us began to talk about Texas as the evening fell. Eating was almost out of the question when it came to talking about Texas cowboys. That was all right with me, of course, because I enjoyed him wanting to experience something different in life, and the least I could do was to encourage him not to give up on his dream to come to Texas. He wanted to make it clear to me that one day he wanted to visit Texas to see the cowboys—and, of all things, a windmill.

As we continued to eat, Lenjoh noticed that the campfire had begun to fizzle out slowly. He then called upon Happy to start another fire, and Happy delighted in doing so, the old African way. Lenjoh and Happy had to work together with the combination of dried elephant manure and two sticks, but they created one of the best campfires I had ever seen—a Boy Scout's dream come true.

As the night grew older, Lenjoh described the next day's safari. It was going to be a long one, and the drive would be even tougher. He had received word from a friend that the roads were very bad in some areas. I told him we could make some other plans for tomorrow, but he insisted that we give it a chance. I guessed that in the back of his mind, he probably felt that he would be letting me down. I left it up to him to make the call. He replied quickly, with a serious look on his face, "We must get an early start in the morning."

Those words prompted me to rise and say good night to the gang, and I disappeared into the darkness of the night, heading toward the

lantern that was hanging in the doorway of my tent. Before retiring for the night, it was only right for me to give thanks and all praise to the Lord for another blessed day.

Fourth Day of Camp

The cool of the morning arrived quickly, along with the orchestra of singing birds, indicating that it was time to get up. It was very difficult for me to get up that morning. It seemed like it was only a few minutes ago when Lenjoh and I were finishing our discussion on yesterday's safari.

As I started to gather my things, voices from the morning darkness began to ring out, indicating that I wasn't dreaming and it was really time to get a move on. I noticed that the staff was beginning to prepare breakfast and that my shower was ready. Escaping from my tent, I dashed quickly to the shower, where my favorite hanging bag filled with hot water was waiting once again for its first customer of the morning. As the cool of the air surrounded my body, I quickly released the hot water, and it painted my body with its heat. Once finished, I made my way back to the tent, only to notice the big orange eye entering the sky as if it were peeking to get a view of the horizontal plain of the African landscape.

Fully dressed and with camera equipment in hand, it was time to make my way to the breakfast table, where Mr. Happy had everything ready for me. Lenjoh looked like he was ready to go, so I ate quickly and made my way to the land cruiser, where he was standing and talking to members of the staff. A quick good morning to everyone was in order, and before I knew it, we were on our way. Lenjoh let me know that we were expecting to see more wildlife on today's safari, which was okay with me. I prepared myself to take some of the most beautiful photographs.

It was not far into the trip before we spotted a Kori bustard, which is a very tall bird with long legs that chooses to move about by walking

or running rather than flying. I could see that spotting wildlife had begun early into our trip, which was a positive sign of what was to come. We continued traveling on the dusty, red road and almost an hour into the trip, Lenjoh wanted to stop and introduce me to one of his good friends, who was known to be a great hunter. I told him it would be a pleasure to meet him, and before I finished talking, we were pulling off the road and stopping in front of a village.

Through the bushy walls that surrounded the village, I could see only a little boy running for cover. Lenjoh entered the grounds of the village to see not his friend, but someone else. After a short conversation, we started back on our way, and the roads began to get rougher and rougher. It was easy to see how the past rains had surgically cut deep trenches into both sides of the roads, which was going to make our day's journey a difficult one. Lenjoh said it was going to take at least three hours for us to reach our destination, and now I could see why. As we moved on slowly, I had to give credit where credit was due, because Lenjoh displayed his expertise when it came to driving in road conditions that changed constantly; the roads were washed out in some areas, and some roads were rocky and steep and strewn with large chunks of granite rocks. I couldn't believe my eyes when I saw people traveling by foot for miles upon miles, walking in the middle of nowhere through these conditions. I had to keep reminding myself that these people had no other choice of transportation; I supposed they could stand along the roadside and ask for a ride when a vehicle like ours came along.

We were almost in our second hour of driving when all of a sudden, a group of baboons crossed the road in front of us. I quickly locked in on the leading baboon as he stopped to pose for me. Lenjoh was kind enough to slow down and maneuver in such a way as to let me take several more pictures of the animals as they moved through the bush, only to disappear from sight.

Once we started driving again, it wasn't long before we spotted more Grevy's zebras. These beautiful animals were made to be photo-

graphed. It seemed like they knew I was a photographer who wanted to take their picture, as they stopped grazing to look up and pose for me. The wildlife was beginning to pop up more often as we traveled farther, and I could tell the difference in the terrain and see the abundant food supply. Lenjoh let me know that the prize feature of the day, when we got to our final destination, would be seeing the black rhinoceros. Seeing an animal of that size for the first time in the wild, instead of a zoo environment, would be something special to me. The trip today even brought us in contact with the Masai giraffe, which looked like a lanky two-story building moving through the bush at tortoise speed.

Giraffes

Lenjoh slowed down once again, and I was able to photograph the male and the female before moving on. Lenjoh took every opportunity to pick up speed when the road conditions allowed it, because the stopping and starting made the trip seem longer. We wanted to be at the

animal reserve, which was a protected area where wildlife could roam freely without their lives being in any danger from the outside world. As we hurried to reach our destination, I could tell that the morning temperature was beginning to be swallowed up by the approaching appetite of the afternoon heat. We knew that more animals could be seen during the cool of the day than in the heat of the afternoon.

Moving on down the road, I could tell that we were getting closer to our target, because the dirt roads began to change color from dark red to off-white. The small, bushy trees disappeared as the landscape began to open up into a large open range where I could see for miles, and wildlife could be seen roaming at a far distance. As I got my camera ready for some shooting, Lenjoh said, "There." He had spotted a family of warthogs dashing through the high grass. I could tell that these guys weren't going to slow down for me to get some good pictures, so I aimed and fired the shutter a few times, hoping that I had captured some interesting photographs for my collection. I couldn't blame them for running for cover, because if I had a rough-looking face and big tusks protruding from each side of my mouth, I wouldn't want anyone taking pictures of me either.

Leaving the slightly faded road, Lenjoh drove across the open terrain, dodging the large ant mounds with ease as we made our way toward the wildlife that was barely visible to the eye. It looked as if we were moving in slow motion, because the mountains in the background that surrounded the vast, open land never seemed to get any closer. Then right before our eyes, a pair of large birds appeared in their black and white uniforms, running and kicking up a cloud of dust as they made their way across the open plains to put a safe distance between them and the land cruiser. It didn't take long to make me believe that ostriches could run so fast. Lenjoh slowed down then, hoping that the magnificent birds would do the same so that I could get some photographs of them. After a few minutes of trailing the birds, they stopped briefly, and that's when I let my camera take over with some serious shooting. They were still some distance away, but that

was okay, because I was happy to make these beautiful birds a part of my photographic library.

As Lenjoh and I continued our quest to look for more wildlife, I had to fight with myself to keep from being hypnotized by the beautiful landscape of Kenya. It was as if God was showing me one of his beautiful paintings here in Africa. Any artist in his right mind would try to capture this fantastic scenery of Africa on canvas. Since I'm not one, the next best thing for me to use was my camera, to paint on film and tell the story of Africa and her beautiful surroundings.

Landscape

After several hours, it was time for us to return to camp, because the drive back was going to take much of the day. "Lenjoh, are we going to take the same route back?" I asked.

"No," he stated, which made me a little happier. He swung the land cruiser into a half turn, and we started our return trip driving over the bumpy mass of land. We continued to look for the number one prize,

as time was running out, but there were no black rhinoceros to be seen. Lenjoh said that the heat of day probably had caused them to move to another location, because the prehistoric-looking animal mostly loves the early morning and late evening. I discovered that their eyesight is somewhat poor but their sense of smell is excellent. My heart was a little broken for not being able to see the rhinos, but I said to myself, *That's all right, because I've been blessed to see so much during my stay. Lenjoh has been an excellent teacher in making me more knowledgeable about the different animals and their habitat.*

Thirty minutes into the drive, we noticed several different types of animals roaming and grazing across the horizon, as if they were assembling for a town meeting. The rays of the sun made their different-colored coats act as prisms, producing a spectrum of beautiful colors that splashed against the dark background of the mountains that sat by themselves afar. As they paraded along, the Grevy's zebras and a herd of Thomson's gazelles were marching together, taking turns scouting the grounds to make sure they were clear of danger from predators.

Even though I took photographs of this amazing gathering of animals, the mother and baby giraffe were the greatest subjects of them all. They stood together for a few moments to let me take several photographs. That morning, Lenjoh had warned me that there would be an abundance of wildlife during the safari, and I can tell you that it was truly wonderful to see so many animals assemble together under the blue roof of God's sky.

Speaking of the sky, Lenjoh noticed that there were a couple of vultures circling in slow motion a short distance away, indicating that dinner was being served at ground level. We drove slowly in the direction of the circling birds to get a firsthand look at what was going on. As we got closer to the scene, it was obvious that there had been a kill earlier that day, possibly that morning. A large group of vultures surrounded the carcass as if a quarterback were calling a play for his team.

Pack of vultures on ground

Lenjoh made a desperate effort to get as close as possible in the cruiser without the huge birds flying off, so that a positive identification of the dead carcass could be made and to allow me to photograph the crime scene. I, for one, had a major problem taking close-up pictures, because I didn't have the correct lens on my camera, and the wingspan on these large birds was tremendously long and wide. As some of the birds surgically cut the flesh from the bones of the carcass with their razor-sharp beaks, others fought one another to have a chance to join the feast. I noticed that just a short distance away from the pack of feasting birds, there stood an uninterested bald-headed vulture, acting as a lookout for any surprise attacks from unwanted visitors. I realized that coming to Africa and being on safari was a great opportunity for me to experience not only spectacular things, but also to witness an animal having its life taken away in a horrible death, which is known as a kill. Yes, it would be a touching experience to wit-

ness a death of any animal, but in order for certain animals to survive, they must live as predators.

Eventually hunger pangs started to hit my stomach unexpectedly. To satisfy my appetite until we returned to camp to get some good cooking, I grabbed a pack of cookies that was lying on the dashboard of the cruiser. After riding for a while with a stomach full of cookies, I began to get a little sleepy from the bouncing and side-to-side motion of the cruiser. Lenjoh spotted more zebras, and they started running along side on the cruiser. I took no pictures this time, because my arms felt rubbery and weak from the heavy camera lens I had carried all day.

I drifted into a short daze, only to realize that after today, I was going to have only one more full day in Kenya. I was having such a great time that it felt like it was still my first day in the bush. Meeting everybody for the first time in my Sunday suit after arriving to camp and having the staff look at me funny would be an unforgettable moment. I asked Lenjoh about other safaris and what he thought would be another good safari for me to take in the future. I told him that I would love to go see one of the greatest mountains of them all, Mount Kilimanjaro. Lenjoh let me know that there were safaris in and around Kilimanjaro National Park, along with tour expeditions of the mountain, which caught my interest immediately. I also let Lenjoh know that as a photographer, I definitely wanted to visit Rwanda to photograph the famous silver back gorilla. He explained that special permits were required, and only a certain number were issued each year. Our conversation came to an abrupt end when he stopped the cruiser in a small rocky area to show me one of Kenya's beautiful Agama lizards.

Standing at attention without any movement, the lizard displayed its reddish-orange head and bluish-green body and tail. The bright sun's rays beamed upon the large rock where the lizard was standing, showing off its beautiful body among the small pile of rocks, which it probably claimed as home. I slowly positioned my camera for another photographic moment.

Creeping off slowly from the rocky area that surrounded us, Lenjoh twisted and turned the land cruiser until we were free to pick up more speed, and we continued to travel over the open plains. I knew he was very tired from driving all day, and I didn't want to spoil his concentration, so I decided to wait until we arrived at the campsite to continue our conversation about other safaris.

For some reason, today's heat wasn't much of a factor during all the excitement of photographing. My body made the necessary adjustments to adapt to the heat. Now I can remember that we did a lot of uphill driving, which probably caused small changes in temperature, and that was the reason we were seeing a lot more wildlife grazing in the area.

It was unbelievable for me to see how Lenjoh displayed his sense of direction over the massive body of land. If there were such a title as "land navigator" and if a ship had wheels, he would be the world's first man called to duty. After driving for almost an hour, we finally turned onto the main road. Lenjoh quickly put his foot to the gas pedal, and off we went, disappearing from the open plains. I turned around in my seat, but the fantastic view of the mountains I had witnessed earlier today had disappeared. The roads and the land elevation were tricky here; a few minutes of driving in some areas would allow you to see the most beautiful country for miles, and a few moments later, you could find yourself hiding in the bush like the wildlife.

As the miles started to add up behind us, the miles in front evaporated quickly as we approached camp. Lenjoh and I noticed a very small moving object coming toward us from up the road, which was a very rare occasion. As it got closer, I saw that it was a motorcycle, and Lenjoh smiled as if he knew the two passengers. He slowed down to a stop, and the two drivers started to speak Swahili or one of the three languages that Lenjoh was accustomed to speaking. It was hard for me to tell which language was being spoken, so I didn't try to figure it out, because my brain had been jouncing in my head most of the day from

all the rough riding. I left the two friends talking and exited the vehicle to take a little walk to stretch my legs.

All of a sudden I noticed an abandoned village across the street. I remembered Lenjoh telling me that villagers sometimes had to relocate because of the long summer droughts that bring harsh conditions, when no food is available for their cattle. I thought about Texas, where we moved because of the heavy rains and flooding; here, the people of Africa moved because there was no rain.

When I saw the motorcyclist pull away, I returned quickly to the cruiser for my camera, so that I could take a picture of the abandoned village before leaving. As we drove off and headed up the hill, Lenjoh, with a smile on his face, let me know that he had once owned the motorcycle the man was riding. Just as we were topping the small hill, I noticed that Lenjoh was driving with one hand on the steering wheel and reaching for his cell phone with the other. He told me that he wanted to stop and make a phone call. He got out and walked up the hill for a short distance, checking to see if he could get a stronger phone signal.

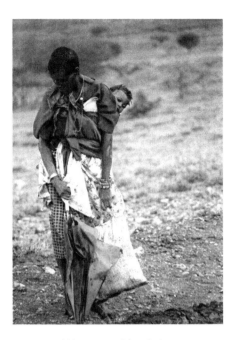

Woman and her baby

I observed a woman struggling as she walked slowly downhill toward us. As she came closer on the opposite side of the road, I had a ringside seat. My heart couldn't swallow the picture before my eyes. She seemed to be in another world as she stared all around, looking up at the sky and then down toward the ground, wiping her sad face, as if hope no longer wanted to be a part of her soul. I could tell that the hot sun was taking out its anger on her thin, feeble body, which wobbled back and forth as she slowly took small steps to continue her journey.

My camera anxiously waited for me to release the shutter, but then I noticed movement from the sagging clothing that draped her weak body. She tried to adjust her falling clothing; to my surprise, the head of a small baby peeked around her shoulder. Its innocent eyes immediately zeroed in on mine as if he were asking for help for his mother. I slowly positioned my camera like a periscope on a submarine as I manually focused on her and the baby. I felt guilty because I hadn't gotten

her permission to photograph her, but my heart convinced me that it was all right because God had something to do with this meeting between the two of us. The Lord was telling me that whatever the conditions may be in one's life, his love, grace, and mercy are sufficient to take care of his people.

I turned to see Lenjoh trotting downhill while still on his cell phone. He quickly made his way in the direction of the cruiser, which was an indication that it was time to move on. As he got in the cruiser and started to drive off, I turned quickly to one side, only to notice that both the woman and her baby were giving me a paralyzing stare that I will always remember. As she slowly disappeared from sight, my eyes stayed connected with hers as we secretly said good-bye to one another.

The time seemed to be passing fast, just like Lenjoh's driving. Suddenly he pulled to the side of the road and stopped. I looked around and said to myself, *Why are we stopping?* As we were in the middle of nowhere, I couldn't find a good reason. Then it hit me that Lenjoh didn't do anything without a good reason. As he got out of the vehicle, he said to me, "We are stopping to get water for camp." Lenjoh and one of the staff began to pump water, while I walked around and observed that elephants had destroyed just about all the trees in the area for food. The clearing made it easy for me to see a newly built African church that was standing tall and proud on a hill. Lenjoh had once told me that volunteers from around the world built most of the new buildings that I had seen. It made me wonder what a great impact it have on Africa if everyone in the world today would only volunteer one week per year for this special cause.

Church on hill

I took a quick picture of the church as a reminder that these people also have souls that need to be saved. Collecting water in large plastic jugs wasn't all that bad, but carrying the heavy containers was a different story. We started on the last leg of the journey back to camp, I realized that we were blessed to have the convenience of a truck to transport our supply of water. For the villagers who had to travel for miles on foot to get water and return to their homes, it was a different story.

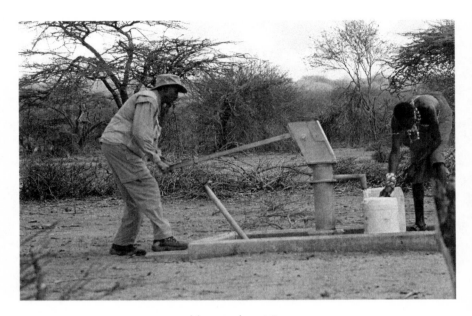

Me pumping water

This trip truly had been a wakeup call for me. Never take anything for granted in your life, not even for one second. It didn't take this trip to help me realize how wonderful God has been to me. It makes me think about the days when I go without thanking him for his love, grace, and mercy.

I glanced at Lenjoh and noticed the picture painted on his face. It made me feel like he was just as happy as I was to return to camp. I knew that he was tired and I should have offered to help drive.

He said that if I wasn't too tired after dinner, a short evening walk would be the highlight of a blessed day. With thumbs up, I let him know that it wouldn't be a problem for me. As we drove up to camp, we saw the gang waiting for us patiently. Mr. Happy, with that patented smile, along with Patiri and Losorogol, had begun preparing dinner. I guess that was why Lenjoh had made several phone calls: to let the gang know our location, which would allow them to have things prepared upon our arrival.

Thanking Lenjoh once again, I dashed to my resting place. As tired as I was, my tent looked like a five-star hotel. I quickly zipped myself inside my tent, dropped everything that was associated with weight, and immediately dove into my bed, as a short-order nap was on my body's menu.

A buzzing sound around my head woke me up only after an hour of sleep. A fly was about to drive me crazy. It seemed like one of my little friends had followed me all the way from the bush without my permission. I pulled out my Sunday school book from my duffle bag, the one I had been reading earlier on my flight to Kenya. It was time for me to put the holy word on this flying pest, and I quickly put it to sleep with a single swing. We had been traveling all day without a fly problem until returning to camp.

As evening approached, the big eye in the sky started to descend to its familiar sleeping place behind the mountains. Mr. Happy made his way to my tent to inform me that Lenjoh was ready for the evening walk. Quickly, I put on my shirt and shoes and hustled out to a ready-and-waiting Lenjoh, who was with another new member of his staff. As usual, I let them start out first, and I followed slowly a short distance behind with my camera, jumping at any photo opportunity that might present itself. I didn't expect to see any wildlife, because the evening sun had surrendered its light, and darkness was beginning to take over.

As we moved and zigzagged through the bush, we saw several promising tracks. Some humans and wildlife are alike, in that they observe the time of day and make their way toward their sleeping grounds for rest as night approaches. The chance of seeing any wildlife was probably slim to none, so I put the cap on my lens and retired the camera by placing it to my side.

We continued to walk several more minutes before approaching a small watering hole, which seemed to be a rare sight in that part of Kenya. There were several different kinds of animal footprints surrounding the small pond, and it was obvious how it could be used by night creatures as an outdoor Jacuzzi.

As we walked, Lenjoh named some of the footprints, which ranged from those of a gerenuk (a small, thin, deer-like animal) to the humongous prints of an elephant. Departing, we made our way back toward camp to have dinner. It didn't take long for us to return, where I noticed a small dinner table prepared with food and a chair with my name written all over it. The campfire lit the evening for some good conversation and relaxation. As I selected my choice of entrée, my stomach produced animal groans like I had never heard before. I immediately sat down to enjoy my dinner, when it hit me: tomorrow would be my last full day on safari here in Kenya.

Slowly my appetite started to disappear as I began to submerge in deep thought, only to remember some of the most important events in my life while here in Africa. Sharing moments with the villagers as I learned some of their customs and traditions will always be stored in my heart until the day God calls my name. I had witnessed the joy in their strong, emotional faces during their tribal dancing, and I had experienced the sadness of their painful living conditions. In the midst of what I had heard and seen, I was glad to have learned from these beautiful people that life is not all about how much one can obtain in a lifetime, or what title one has in front of or behind one's name. It's about being happy with what the Lord has allowed you to have, even if it means living the simplest form of life. I asked myself, could I live the life of a Samburu or Laikipia Masai? Without thinking, I knew the tables could easily be turned, and I wouldn't have a choice in the matter. God had spared me and allowed me to visit Africa in a blessed way through the lens of a camera, and to tell a story of a special place and special people with hearts the size of the continent in which they live.

As Lenjoh quickly joined me for dinner, he sense that I was in paralyzing deep thought, or out of my mind. He asked me, "Everything okay, Carlyle?"

I looked at him as he parked his tall, thin body near the campfire with a plate of food, and I replied, "Of course." I asked him to take a seat and have dinner with me. I slowly let my mind exit the deep

thoughts about all the events I had experienced while on safari here in Africa. The two of us began to talk about him coming to America to visit, so that he could experience firsthand the life of the American cowboy. Before we knew it, dinner was no longer on our minds, and one topic led to another. I wanted so badly to help him come to Texas, and if the Lord continues to bless me like he has in the past, Lenjoh will be given the chance of his lifetime to fulfill his ultimate dream. Without any doubt, he has truly been a blessing to me, because I know for a fact that there was no way I could have experienced an African safari the way I had without him. I do not know when, where, or how, but using a line from Dr. Rev. Stanley T. Hillard, "I have a Godly guess and Holy hunch" that one day Lenjoh will be able to stand proudly on Texas soil as an American cowboy.

As dinner was about to come to a close and the campfire showed its sleepiness as the flame disappeared slowly, I told Lenjoh that I would love to return to Africa someday. I got up from the small table, and as I walked off, saying good night to everyone, I looked back to see his large smile, which lit up the campsite as if someone had thrown more wood onto the fading fire. It was time to close another blessed day that I would never see again.

I realized that I didn't have my flashlight with me, so I gingerly took small steps as I vanished in the curtain of darkness, heading back to my tent for a good night's sleep. Upon entering the tent, I made one final glance toward camp, and I saw the silhouettes of Lenjoh and the gang surrounding the dwindling campfire, which reminded me of a large, lit candle sitting on the ground.

Once inside my tent, I began to get my clothes ready for my last full day of safari. It was good to know that I had lived five days in the bush here on the African plains. I thanked God for what he had done—and if it was his will, what he would continue to do for the wonderful people of Africa.

After gathering everything together, I finally jumped into bed for the rest and relaxation that I'd been waiting for all day long. Over the

past few nights, I could sometimes hear Lenjoh and the staff talking during the night, but for some reason it wasn't so tonight, as I could only hear the mixture of musical voices from the wildlife. Some were singing, while others had their own special way of speaking to one another. I looked for my diary, so I could record the day's events. I continued to write into the night, until the voices of the wild could no longer be heard. I guess this was an indication that it was also time for me to say good night. Dropping everything, I quickly covered myself against the cool night air, and I rolled over into a paralyzing sleep.

Fifth Day of Camp

After tossing and turning for most of the night, I could no longer sleep for thinking about spending my last full day in Africa. The darkness in my tent made me aware that the morning light was still a little way off. I didn't want to waste any more time lying in bed and waiting for daylight, so I decided to jot down a little more information about yesterday's safari in my diary. I reached to turn on the lantern that was suspended above my head, only to find that the lighting was beginning to dim, which indicated that the batteries were losing strength.

I quickly got out of bed and started fumbling in the darkness, searching for my flashlight. Getting on my knees, I swept the tent's floor with my hands. Once my light source was in hand, my diary was quickly supplied with valuable information. I continued writing until the morning choir of birds began singing once again with their beautiful morning voices that indicated daylight was just around the corner. It wasn't long after that before I began to hear voices coming from the staff tent area; preparations were on the way for today's safari. Like me, I guess Lenjoh and the team used the same alarm clock of nature that helped us all get up to rise and shine each morning.

Before Happy could get to me this morning for his normal wake-up call, I wanted to surprise the staff with a special good-morning and show my thanks for their good deeds. As the morning light twinkled through the bush, I started on my way to the other side of camp to say my good-mornings. But before I could get close enough to the camp-fire where everyone was sitting, the echoes of good-mornings rang out and attacked my ears from all directions.

I noticed that Lenjoh was all ready to go. After I said good morning to everyone, Lenjoh and I discussed the safari agenda. It would consist

of a combination of walking and riding, in addition to camp being set up on the same river as the first day, but in a different location. I didn't want to delay the starting time, so I quickly departed from the gang to head back to my tent, so that I could grab a few things to take my shower and get a little breakfast. It was unusually cool that morning. Once at the shower tent, I quickly solved the problem by opening the nozzle of the water bag, and I stood underneath it to let the earth's gravity do its work by pulling the warmer water out quickly to soak my entire body.

After making my way back to my tent to get ready without any more delays, a strange feeling rushed over my body. It was a feeling of being guilty—for what reason, I just didn't know. I dropped to my knees to gather my camera equipment, and I glanced over at my duffle bag, which contained all my clothing. This feeling continued to get stronger and stronger as I opened the bag to make a quick inspection. There I was in the middle of no man's land, asking myself why I should be feeling the way I did. The answer came to me in a soft, sweet voice, telling me to leave my clothing. I turned around on my knees and leaned on my bed to pray. The Lord had been so good to me that he allowed me to travel halfway around the world to meet some of the kindest people that ever lived, who had so little to give but so much to share. I now had to share in return the clothes that the Lord had blessed me with. When I understood what was going on with me, the feeling disappeared instantly, and I knew that to obey was the right thing to do. I closed the prayer with an Amen, and before leaving my tent, I emptied my duffle bag to separate out the clothing to be given to the staff.

It was time for breakfast, and I made my way to the African restaurant that was located around the morning campfire. Once again Mr. Happy had everything ready and in place for me. As I gathered what I wanted to eat, Lenjoh made his way over to join me for breakfast. We discussed today's safari from the start to the finish and he told me what to expect. To my surprise, Lenjoh let me in on the event that was going

to close out today's safari: the grilling of a goat and the drinking of its blood. I had heard that goat's meat was very good, but the drinking of blood definitely was out of the question. Before he could finish talking, I rose up quickly, indicating that I was ready and anxious to go without finishing my breakfast. Before our conversation could come to a close, the subject of Texas popped up, unannounced; Lenjoh made it clear that he wanted to be a cowboy, and I told him that if he ever had a chance to come to the States, I would help him fulfill his dream. I also made a secret promise to Lenjoh that I would buy him a complete western outfit once I returned to the States.

I ran back to my tent to make sure I had everything, while Lenjoh went to check on the land cruiser. Everything was intact, and I quickly made my way to the cruiser; a driver sat inside, and the roaring engine served notice that it was time to depart. As Lenjoh had stated earlier, today's safari would return us to the deep banks of the red river that supplied life to all living creatures that wanted a drink in the early morning, at noon, or at night. Some of the staff was to stay behind to prepare for the closing night's festivities, while the others would go ahead to meet us upon arrival at the temporary campsite, where lunch would be served on the riverbank.

As we drove off, good-byes were in order, and then we followed the faded dirt road that entered the maze of the low-spreading bush. Sadness started to make my heart flutter when I realized that tomorrow would be my last day of hearing the early morning greetings of Mr. Happy and the temporary good-byes that were said before each day's safari. Would this be the final good-bye from my newfound family?

Trying to remove the thought from my mind, I struck up a conversation with Lenjoh, asking where our first stop was going to be. He said nothing, just pointed in the direction of the large mountain that stood alone, suggesting one last visit. Lenjoh wanted to approach the mountain from the opposite side from the first time we'd made the climb—or, I should say, when he and Happy had made the climb to the top. I guess there is nothing for me to be ashamed about, because

for my first time climbing any mountain, I think I did very well to get only a few feet from reaching the top. If I had to make an excuse for not reaching the summit, it was because of all the camera equipment that I was lugging around.

Once at the base of the mountain, we exited the cruiser and quickly made our way up the mountain. As I went higher, I kept looking back to see the beautiful scenic view that God had placed before my eyes. I turned around and looked up, and I saw that Lenjoh and the warrior were almost to the summit. I stopped to take a few photographic land-scape shots of so many of Kenya's beautiful mountains. This side of the mountain was a lot easier to climb because of the position of the rock formations. It was like walking up a staircase.

I continued to climb, but I couldn't resist making several stops to take pictures. Lenjoh and the warrior had already conquered the mountaintop, and they'd immediately spotted wildlife moving far off in the distance. I didn't want to miss seeing the animals, so I quickly made a few moves, and before I knew it, the summit was within my grasp. Just before I made my final step to the top to join Lenjoh, I took a few steps backward to photograph these two great Samburu warriors, as both stood tall and were highlighted by the blue background of the sky.

With a couple of high kicks, I stood alongside my friends. Lenjoh handed me the binoculars and pointed to the Gant's gazelles walking proudly while searching for grass in the far distance. The 360-degree view was so amazing and fantastic; it would make anyone's eyes sparkle like diamonds on the hands of an African queen. After standing for some time, the three of us stopped to sit for a while before moving on to the campsite. I surprised myself when I noticed that being so high on the mountain hadn't fazed me at all.

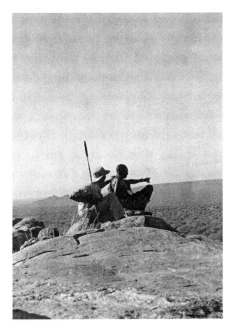

Me and my tracker

After a few minutes passed, Lenjoh, in his native tongue, indicated that it was time go, because it was getting close to lunchtime. Before we started back down the mountain, I passed my camera to Lenjoh, asking if he would take a picture of the warrior and me sitting on the mountain's summit, searching out life among the bush.

Once we had made the trip down the mountain, we pushed to our final destination without any hesitation. For the first time, Lenjoh and I stood up in the back of the cruiser while riding in the low-lying bush, which provided a good view of things while adding more flavor and meaning to the word safari. This was the first time that I had ever experienced the feeling of being lost while traveling. Being in the bush always looked as if we were going in circles while bouncing on the rough, angry roads.

We approached the river, and the staff that had gone ahead of us had camp already set up and fully operational. The smell of good cook-

ing teased my appetite. The makeshift restaurant served its purpose very well, and I was happy to arrive in time to get a little relaxation while lunch was being prepared. After sitting down a little, I got up slowly to walk along the deep riverbank as the red water speedily passed by me like a rushing subway train waving good-bye as it snaked its way through the bush, trying to meet its schedule. Looking at the sandy banks, you could tell from the animals' footprints that there were many visitors that stopped by to quench their thirst as they made their nightly travels. With my camera in hand, I continued to walk gingerly; the soft, loose sand could tear away any time from the banks and easily deposit me in the rushing waters of the river. As I picked my spots to take some beautiful photos of the area, a particularly tall, flat-topped tree caught my eye almost immediately. It looked as if it were standing guard like a soldier at his or her post.

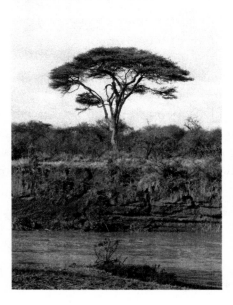

Tree

I lifted my camera to delight my eyes as I focused on the tall, handsome figure of a tree towering proudly above the low-spreading bush. Its roots pierced through the red dirt of the riverbank, searching for water to drink. This spectacular view would be one of my favorite photos taken while here on safari. The Lord had put one of his beautiful paintings right before my eyes to be photographed. I continued to take additional photographs, and from a distance, a small, blurred figure slowly entered in the corner of my left eye. I turned my head slightly and saw that it was one of the staff members approaching, as if he was serving a summons, to let me know that lunch was ready. This tall, slender man was equipped with all the tools of a hunter; he carried a large knife and a razor-sharp spear, and he got my undivided attention. I quickly hit the camera's off button and followed him back to camp for some lunch.

Lenjoh, waiting in the wings for me, was already sitting with a large smile on his face. He had chosen the perfect place to have lunch, right under a large tree next to the riverbank; the tree provided excellent shade and produced a cool breeze from its swaying back and forth, which blew in our faces. As I was selecting what I wanted to eat from the small table of delicious food, I continued to talk to Lenjoh about the remaining day and evening activities.

After I sat down to eat, it wasn't long before one of Africa's beautiful little birds landed on a flower right in front of us. It was a little smaller than a hummingbird; it was all black with a spot of orange on his throat. Lenjoh told me to observe what the bird was going to do. I couldn't believe my eyes. This little bird entered the petals of the flower with its beak slightly open, not to rob it of its nectar, but to water it. I had to stop eating to really see what my eyes were presenting to my brain. I tried to reach for my camera for a quick photo as the little fellow carried on his duties, but I wasn't fast enough, and the tiny black dot disappeared for cover among the branches that extended over the river, giving the tree's large leaves a chance to scoop water from the rushing river.

I quickly returned to our conversation about the closing day's events as Lenjoh dispatched his men to get water from the river. I looked at Lenjoh and the two men, and to my surprise, there was a young little boy with them that I hadn't seen before—a future Samburu guide, I thought to myself. These kids start early, learning the way of life, and there is hardly any playtime after meeting the family's needs and trying to obtain what little education is available to them.

I redirected my attention to Lenjoh. I believed he had mentioned the sacrifice of a goat when we returned to camp. Listening to him talk, it seemed to be a tradition among the Samburu people, especially when there were guest on safari. As our conversation continued, it took us around the world, from Texas all the way back to Africa. Just as lunch was coming to an end, I noticed the men return to camp after getting water from the river. The young boy among them caught my attention immediately, and I asked Lenjoh if was all right for me to photograph him along with one of the Samburu guides.

As I walked to find a good location along the river, I noticed that the young boy and the tall Samburu guide were on my trail, following right behind me. As the two came closer to me, my eyes immediately zeroed in on the shame that was written all over the boy's face as he was about to play his first role as a young model being photographed. I considered myself very blessed to have the opportunity to use one of God's many studios on the riverbank of this beautiful country.

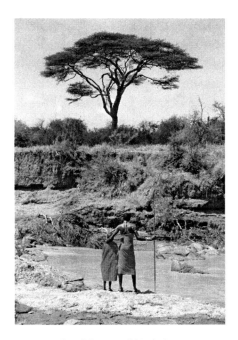

Small boy and his father

Seeing the two standing alone, looking over the river's rushing water, brought to mind a father taking time to give advice to his son, telling him about the life as a young male. Without lifting up my camera, my eyes had already taken a visual photograph of the two, because it was hard for me to concentrate when I realized that in Kenya, children play a vital role in the family's functions each day. At an early age, they are given great responsibilities that will help them as they grow up to be men and women. The difference between our kids and the children in Africa is that kids in the States are surrounded by so much crime and violence, along with so many other things to distract their young minds. In Africa, crime and violence is substituted with survival and meeting the daily needs of one's family or village.

With the sun beaming down on us, I quickly made a few serious photo shots. I finally shot the last frame of pictures, and the photo session was over. We made our way back to the temporary camp to get a

little relief from the sun and quench our thirst before returning to the main campsite. I saw Lenjoh standing under the tree, waiting for us. When I thanked him for his patience, he smiled and said, "Let's head back to camp before the day gets too old." Our journey back would consist of both riding and walking. It was the hottest part of the day, so I did not expect to see many animals, because they take their rest periods just as humans do. Lenjoh was surprised that we hadn't seen more elephants during this week of safari. He said that a few days before my arrival, there were plenty of African elephants in the area, and they had passed through Tumaren Ranch.

We quickly loaded the land cruiser with a few supplies and started back to the main campsite, while some of the staff remained behind to finish cleaning up and to bring the remaining supplies later. We slowly made our way back through the bush, looking to spot anything moving, because when you think there is nothing around to be seen, that's when some exciting wildlife could easily cross your path. I missed so many good shots because of this reason.

Lenjoh advised me to take a short nap once we arrived in camp, because he wanted me to be ready for an evening to remember. It was good to know that these guys were going all out for me, and I felt so helpless not being able to repay them.

As we entered the campsite, Mr. Happy, along with a few new faces that I hadn't seen before, greeted us upon our arrival. I began wondering to myself why there were so many new faces. Without trying to figure out the reason for the increase in camp activity, I made my way to the temporary home that had housed me over the past few days. Sadness began to overtake me, because I knew everything was coming to an end the next day. Yes, I really did miss my family and friends back home, but for the past few days, my new family had really taken care of me, and I was definitely going to miss them.

Without any hesitation, I jumped into bed and once again secured my diary with a tight grip. I jotted down some notes about that day's riverbank adventure. After a few pages of writing, I began to get sleepy,

and the last thing I could remember was the little boy waving good-bye to me as we drove from the camp earlier that day.

As I arose from a deep sleep, I realized that the safari had taken its toll on me again, because I had slept longer than expected. Without getting up, I lay on my back for a while, staring in a daze with blurred vision at the top of my tent as the memories of my grandparents entered in and out of my mind. My grandmother and mother always told me not to be selfish, but instead to share with others, even if it meant giving little or my last. I thanked the Lord for all the "grandparents and parents" that had passed on to be in the glory of the Lord.

Knowing that I had to get up, I rolled over and sat on the bed to quickly put on my shoes. With my eyes still a little blurred from the hard sleep, I bent over to tie my shoes, and as I looked up to clear my eyes, I saw that my laundry had been done for me and my clothes were neatly folded and placed in the dark corner of the tent. Without putting anything away, I quickly decided that the clothes weren't going to travel back home with me. I made several stacks of clothing according to the number of staff members that had been in camp with me since I'd been on this wonderful safari. I was hoping there would be enough clothing to share with each staff member, to show my appreciation for what they had done for me over the past few days. Having an eye-opening experience had made me realize that there was an Africa. Yes, I'm just as guilty, but it would be an excellent time for me to begin my missionary work for the Lord.

Leaving my tent to join the others, it was apparent that the camp-site's population had increased. There were some new faces that I hadn't seen before. *Well,* I said to myself, *it's time to meet some more new friends.*

As I started my short journey toward the group of people, I could barely hear a feeble whining sound that was coming from somewhere within the small camp. There I was, interested in a strange sound when I should be joining my friends and celebrating the closing of an excel-

lent safari. Tonight would be the highlight for me as I prepared for my trip back home the next day.

As dusk began to fall, Lenjoh walked up to me and suggested that we take a small evening walk through the bush to see if we could spot any wildlife for the last time before nightfall could swallow us up without any warning. It would give the staff time to get everything ready for the closing night's events. I marched back to my tent to get the camera, in the event that there might be a chance of getting some great last-minute shots of wildlife, even though it didn't look like I would be able to.

We headed for a small opening in the bush. All of a sudden I noticed a goat that was tied to a tree right on the edge of camp. I realized then what had been making the pleading sound I had heard earlier. My heart went out to the small, innocent animal, because I felt that I was to blame for what was about to happen to it. As I disappeared into the bush, my ears started to tremble from hearing the goat begging for its life, as if the animal knew it was about to be a sacrifice for my cause. As we continued deeper into the bush, the sound of the goat faded out slowly as was replaced by the wild's evening choir of beautiful voices that filled the atmosphere just before the end of day.

While we were walking along, searching for anything that might move, Lenjoh made me aware of the activities that I was going to witness when we arrived back at camp. The first thing he mentioned was the sacrifice of the goat for its blood and meat. As I had learned earlier doing my stay here, the drinking of blood was a tradition of the Samburu people. I let him know instantly that I didn't like seeing an animal lose its life, and I asked if it was okay with him that I not witness the sacrifice. Lenjoh could tell by my reaction that this wasn't something that I was in favor of seeing, and he told me that he understood, with a big smile. He also let me know that the grilled meat was delicious, and I was willing to taste it without any problem.

As we marched back into camp, the first thing I looked for was the innocent little goat, which had already been led off to its final sleeping

ground. It took me a while to catch on to what was happening, but I finally realized that it was why we had a few more visitors, because the Samburu people take the feasting of an animal seriously. I could see that sharing among one another meant something very special to these beautiful people. It made me feel so warm inside as they went out of their way, continuously trying to make me more knowledgeable of their culture and traditions.

Lenjoh and I departed on our separate ways; he made his way toward the large campfire to join the others. I pressed on in the direction of my tent, speaking and waving to everybody. Upon entering my tent, I felt a little tired, so I put away my camera equipment and sat on the bed for a brief moment before returning to the main attraction for the night. Knowing that this would be my last night, I decided to gather what few things I had remaining to take back home after giving away all my clothing except for one change of clothes and what I had to wear before returning home. I knew that the affair was probably going to run a little late into the night, and packing so late was going to be the farthest thing from my mind. The very first important thing that I made sure I didn't forget and leave behind was my diary. My camera equipment could easily be replaced, but being able to experience just a tiny sample of the lifestyle that my ancestors once lived, and being able to tell the story of what I had learned in just a few days—these things truly were blessings for me.

It was time for me to join my friends for the last nightly dinner and a celebration of my first successful safari. As I made it to the main stage, where everybody was having a good time, I could see that Mr. Happy and the other staff members were putting the final touches on dinner. I noticed that there were two fires burning tonight, for some reason. I asked Lenjoh about the smaller campfire, and he replied, "That's not a campfire. It's the cooking area for the grilling of the goat."

They didn't waste much time before they started cooking the goat, because it seemed like it was only a few minutes ago that the animal

was tied to a tree, waiting for a visit from death. I quickly excused myself from the group and made a beeline to the cooking arena, where I saw one of the oldest ways of cooking that history has preserved. This method was cooking in a hole in the ground filled with hot coals and a flat piece of wire mesh. This way of cooking brought back some memories from back when I was a little boy. As the cooks from both kitchens made their final preparations for dinner, I made my way back to the main campfire, where the gang was waiting anxiously for the main course. The cooking of a goat must have been really special, because I never saw so many happy people at one time, waiting for dinner to be served. As they communicated with one another in their language, I could only sit and imagine what they were speaking about.

As I sat at the small table for the last time, Mr. Happy brought me a plate of food topped so high that my appetite spoke to me, saying, *No way.* Not long after Happy served me, I looked up to notice that the main course was being delivered to the kitchen. Happy sliced me a piece of the grilled goat's meat. I was really hungry for the first time while on safari, and I was surprised by the taste of the meat; it was better than I thought it would be. The others started eating, and in a matter of minutes, the meat from the goat was quickly devoured. Now I saw why Happy was in such a hurry to make sure I received my serving. It vanished instantly, like a kid going into a candy store with one dollar. I lost my appetite almost immediately when I saw their blood-soaked fingers as they finished off the remaining supply of goat meat. It was amazing to me how rarely they ate meat. They giggled and made fun of me while they were cooking the meat, as I requested that my order be cooked well done.

As dinner came rapidly to a close, food-filled mouths made it a little quiet; hardly anyone did any talking, which was a huge difference from the beginning of dinner. We sat around the campfire, surrounded by total darkness while staring at the fire's constant waving flames and the popping of hot coals, trying to make conversation with anyone that was willing to talk or listen. Then all of a sudden, beautiful singing

flowed from a hidden voice among the mumbling voices of the men. I tried to locate the face with the voice by looking through the bright orange-colored flames that highlighted each one of our faces, but darkness refused to give me any help, making it almost impossible for me to see. Almost immediately, a few more voices joined in, and the singing became louder with each additional voice. The magnificent sounds of these men's voices flowed through the darkness of night, bouncing off the mountains that stood in a distance and silencing all sounds coming from wildlife. I knew something was about to happen, so I quickly dashed off to my tent to retrieve my camera. As they continued to sing, their jazzy, musical voices made the men rise to their feet. Lenjoh joined in to do the ceremonial dancing that they were known for in Africa. Grouping close together brought on the special effects of their dancing and singing as they jumped very high, straight up and down, trying to get a fresh breath of air away from the cloud of dust produced by the patting of their feet on the earth's dusty floor.

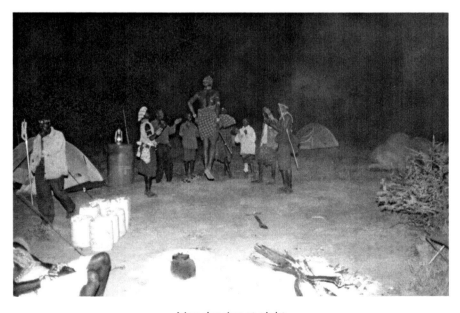

Men dancing at night

After seeing the production, it was time for me to put my camera to work for a little night action. One by one, each man took his turn soloing part of the rich African songs that caused a warm, loving sensation all over my body. It produced goose bumps and made me shiver as if I were wearing a sleeveless shirt and standing outside on a cool early morning. Over the past few days, these African men and women had performed so well. They had been rehearsing for days, waiting upon my arrival to display their unique way of dancing, knowing that I was going to be the only one in the audience. I thanked the Lord for what my eyes had seen and my ears had heard, because now Africa would always have a special place in my heart.

After sitting full of good food, I was having a good time and wanting the last night to be the highlight of my African adventure. I was about to call it a night, when all of a sudden the singing and dancing slowed down and came to an end. It got me off the hook from disappointing Lenjoh and my friends by telling them it was my bedtime. Lenjoh left the group of men and walked over to me, a little exhausted, with a huge smile on his face that lit up the campfire. He pulled up a chair so that we could have our closing conversation for the night, regarding the plans for my departure the following day. This was the first time sad news had entered my ears while on safari. As I sat, not totally listening to him talk to me, I couldn't determine which was going to be my saddest moment, leaving Africa and my special friends or experiencing the way of life in which these people lived to survive each day. I refocused my attention and thanked him for his kindness and everything his group had done to make my visit a success. Even though I knew it was his job, I felt in my heart that this trip was something special to both of us, based on the conversations that we'd had each day.

As the remaining men returned to the campfire, some chose to stand, while others grabbed a seat or whatever object they could find to sit on. I said my goodnights to all, offering my seat to anyone who might be interested. I then made my way slowly to my tent, and I gave

a special wave to my dearest friend Happy. Upon entering my tent, without taking off my clothes, I fell to my knees to give thanks to my lord. I realized that if it wasn't for him, this great experience wouldn't have taken place for me, which is why I give him all the praise and the glory. Getting off my knees, I figured that my gifts the next day would be something special to the men, but this wasn't enough. I made a vow to myself that upon my arrival back in the States, I would make a plea to my church to help the people of Africa. I climbed into bed with my eyes barely open, picked up my diary, and turned slightly toward the hanging lamp to enter the minutes of the day for the last time while on African soil.

Final Day of Camp

Without getting much sleep, I awakened early to face the fact that this would be my last time to hear the choir of singing birds that introduced themselves each morning to an unknown stranger. Yes, I would miss the freshness of the cool air that slapped me in the face each morning, as it entered my nostrils to jump-start the flow of blood that circulated through my body. It was my medication each morning, and nature provided it for me while I was in Africa.

I quickly emerged from under the warm covers as the coolness of the air pressed against my body, making me rush to take my early morning shower. Standing under the large water bag, I noticed there was something different about this morning. Then it hit me: I hadn't heard from Happy, which was unusual, since it was my last day. After getting back to my tent to get dressed and perform a thorough search to prevent leaving anything behind, a surprising voice called my name. I just knew in the back of my mind that Mr. Happy wasn't going to let me down this morning with his special introduction to breakfast. It was going to be a light meal for me this morning because of the long drive that stood in front of us. I challenged myself to see if I could figure our way out of the bush, but with my mapless memory, there was no way in the world I could make it back by myself.

As I exited the tent, Happy was standing and waiting for me. The two of us took our final walk together to the main camping area. Lenjoh was sitting by the campfire as I walked up to be blasted by the many good-mornings. The smiles from everyone's faces made the campsite light up that much brighter as the morning sun tried its best to peek over the low-standing bush. Lenjoh was all smiles as I pulled up my chair to sit next to him. When there weren't too many others

standing around next to us, I quietly asked him to meet me back at my tent after breakfast, to which he agreed. I also let him know that the grilling of the goat the previous night was great. I told him that without a doubt, the singing and dancing were the highlight of the night, and it had been a breathtaking experience.

After we finished breakfast, Lenjoh ordered his staff to pack some of the equipment that was going back with us. The two of us marched back to my tent, where our private conversation started almost immediately. I informed him that just a few days ago, I had made a decision to give his staff my clothes, to be shared among each other. Before I could finish saying what I had to say, a quick thank-you parted his lips, followed by one of his famous smiles. I asked him if it would be all right for me to take a few more photographs of my friends for the last time before leaving, and without any hesitation, he gave me his stamp of approval.

Turning to go back inside my tent, I asked Lenjoh to call over his staff, and I handed over the clothing to him. The staff gathered quickly, as if they knew what had been on my mind all along. As Lenjoh distributed a few pieces to each one of them, explosions of smiles burst all over their faces like fireworks bringing in a new year. I had to fight back tears when I saw them standing around like little innocent children waiting to receive a gift for the first time in their lives. Without putting my hands to my chest, I could feel my lungs inhaling and exhaling as if they were trying to warn me that they were about to take their last breath. It meant so much to me to change the tide for the first time, to have the opportunity to say thank you to my special friends without receiving one in return.

I must keep in mind that God has truly blessed me in letting me travel all around the globe and meet so many wonderful people from different cultures and with different traditions. I, a total stranger, have been invited into their homes, as they trusted their loving hearts that neither harm nor danger would come to them. I keep reminding myself, as my pastor would always say, "When anybody does some-

thing for you, the least you can say is thank you." I didn't want Lenjoh to think that I had forgotten all about him and what his gift was going to be, so I told him to expect to get his gift in the mail a few weeks from then.

When the gift giving ended, I gathered my old duffle bag and camera equipment and headed to the land cruiser for my journey back home. Giving my things to one of the staff members to put in the cruiser, I turned for a final view of my African home for the past six days. As I stood staring for a few minutes, I wept inside, and we said our good-byes to one another.

Seeing how the heavy activity was beginning to pick up a little with the closing of camp, people began to move around like ants searching for food. I quickly pulled out my camera to take a few more photos. These photographs will be the treasure of my life to show and tell the world about another world and its hidden people. I quickly gathered Lenjoh and the staff for a group photo, to display the power of the togetherness of the Samburu people. Lenjoh had me to join the group, and he made a few photos of his own.

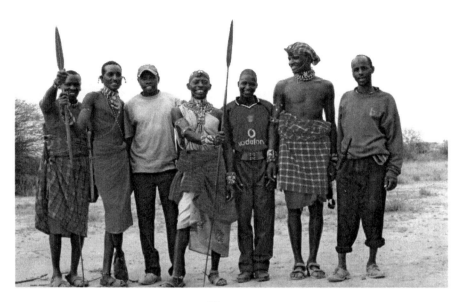

The gang

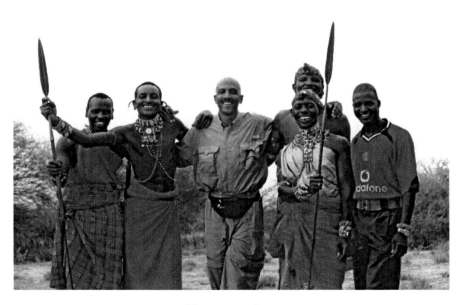

The gang and me

After the pictures were taken, the staff then led me to an area on the grounds where they displayed fine handmade jewelry from the village in which they lived. Without any hesitation, I made purchases to support their families and other members of their village.

As the time got closer for me to depart, the handshakes took center stage, followed by the final good-byes. Their loyalty and generosity to me will always be special, and the smiles on their faces will be remembered and stamped on my heart for the remainder of my life. I asked everybody to join hands, and we formed a circle to pray, led first by Lenjoh and then myself.

Mr. Happy walked up to me for a personal handshake as the others stood in the background. I told him that our relationship wasn't ending but just starting. Happy and a few others stayed behind, while a couple of the staff joined Lenjoh and me in the land cruiser as we started to drive off. Turning around to wave good-bye, I realized that the dust had swallowed up my friends and the entire campsite.

As I stared straight ahead for my final time on the red carpet road that flowed away through the bush, leading me back home, I could hear a soft voice asking me, *Will you be coming back soon?*

I could only answer, with a smile on my face, *I'm leaving as a tourist and photographer today, but I'll return some day as a missionary to Africa, home of the world's rock of salvation.*

Index

Page numbers in **bold** refer to photographs

978-0-595-69188-3
0-595-69188-9

CPSIA information can be obtained at www.ICGtesting.com
Printed in the USA
LVOW090842181011

250976LV00002B/78/P